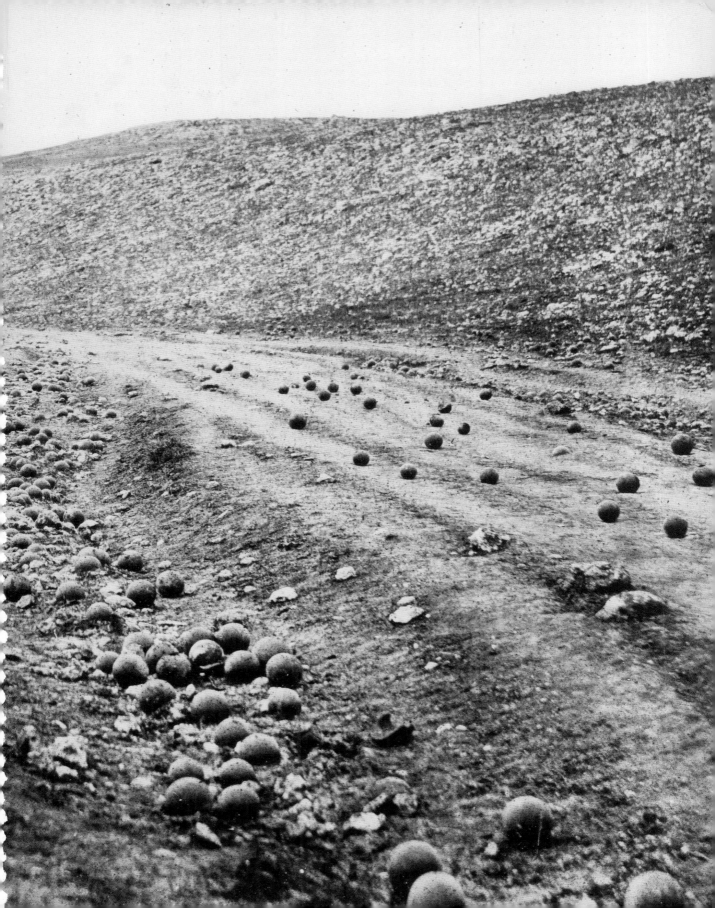

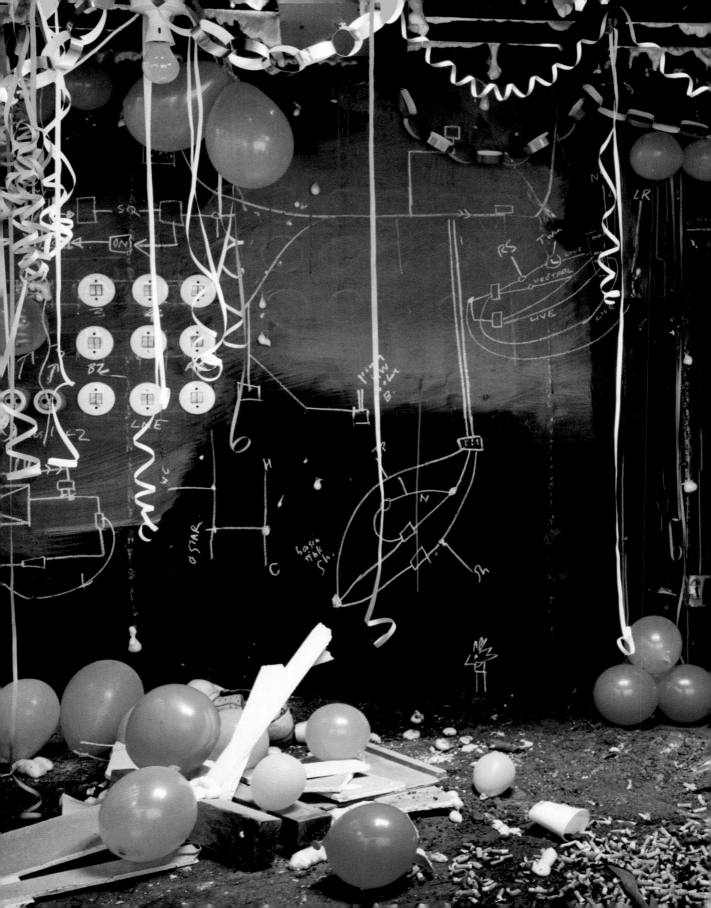

V&A Photography Library

Making It Up: Photographic Fictions

Marta Weiss

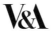 Thames & Hudson | V&A

With 146 illustrations

Published to accompany the opening of the V&A Photography Centre
at the Victoria and Albert Museum, 12 October 2018

Making It Up: Photographic Fictions © 2018 Victoria and Albert Museum,
London/Thames & Hudson Ltd, London

Text and V&A photographs © 2018 Victoria and Albert Museum
See also Picture Credits p.187–9

Layout © 2018 Thames & Hudson Ltd
Designed by Loose Joints

First published in the United States of America in 2018 by Thames &
Hudson Inc, 500 Fifth Avenue, New York, New York 10110.

www.thamesandhudsonusa.com.

Library of Congress Control Number 2018945314.

ISBN 978-0-500-48037-3

Printed and bound in Slovenia by DZS-Grafik d.o.o.

V&A Publishing
Supporting the world's leading
museum of art and design,
the Victoria and Albert
Museum, London

Titles in *italics* have been assigned by the
photographer or artist. Those in roman are
descriptive titles.

On the cover: Detail of Trish Morrissey, *Untitled,
2001*, 2001 (see p.118).

p.1 Detail of Roger Fenton, *Valley of the Shadow
of Death*, 1855 (see p.173).

p.2 Detail of Anne Hardy, *Untitled IV (balloons)*,
2005 (see pp.182–3).

p.6 Detail of Henry Peach Robinson, *Fading Away*,
1858 (see pp.124–5).

p.12 Detail of Gregory Crewdson, *Untitled*, 2006
(see pp.24–5).

Contents

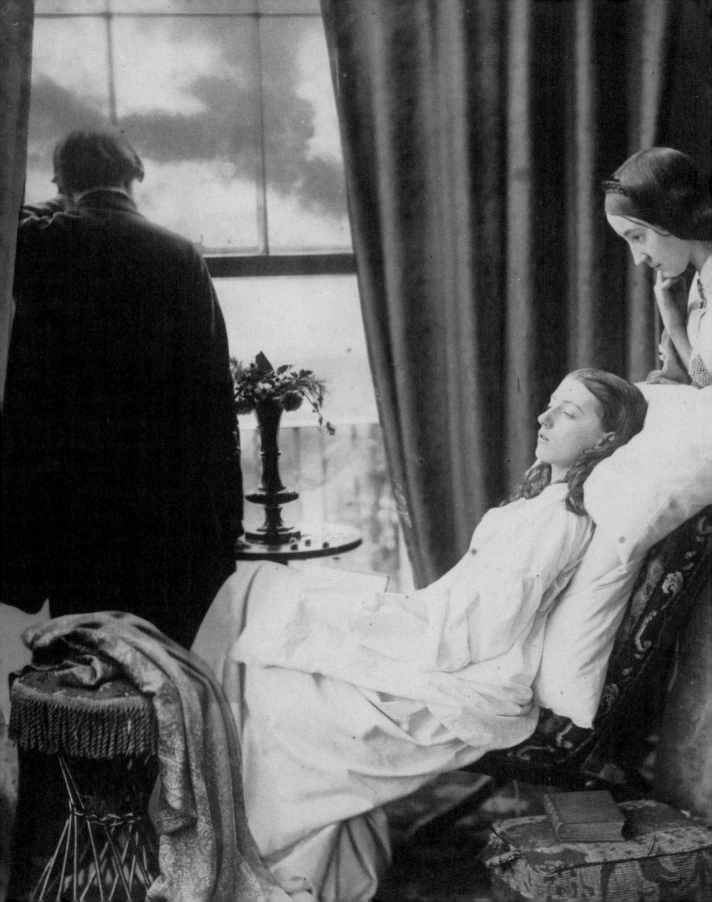

Marta Weiss Making It Up: Photographic Fictions

It has been said that the camera never lies. Yet throughout its history photography has consistently been used to depict fiction rather than fact. The staged, constructed or tableau photograph has been a widespread feature in contemporary art since the 1970s, but the first storytelling photographs were created shortly after the medium's invention was announced in 1839. The urge to create photographic fictions is almost as old as photography itself.

Drawn entirely from the permanent collection of the Victoria and Albert Museum (V&A), this book includes work by some of the earliest as well as some of the most recent photographers to make things up for the camera. They employ a range of strategies. Some use costumes, props, sets and poses to tell an entire story in a single image. Others create sequences in which the action unfolds from one frame to the next. While some artists depict recognizable stories, others present enigmatic, frozen moments that they leave to the viewer to decipher. Many refer to other narrative forms, such as literature, film, painting and theatre, and some even create photographs that imitate other photographs.

For many of its earliest proponents, staged photography promoted the artistic value of the new medium. Since narrative had long been accepted in painting — whether in grand history paintings or domestic genre scenes — some photographers tackled such themes in order to stake a claim for photography as an art form. Setting up a scene in front of the camera, rather than photographing events spontaneously, was also compatible with the long exposure times early photographic processes required. For more recent practitioners, staging is often a means of referring to the artifice of contemporary culture.

This book opens with a tableau staged in 1845 on the estate of William Henry Fox Talbot, one of the inventors of photography (p.15), and closes with an unsettling and strangely vacant room constructed in 2005 by the artist Anne Hardy (pp.182–3). The pages in between are not arranged chronologically; rather, they are grouped loosely into themes that flow from one into another, bringing images made decades apart into dialogue with each other. The Talbot and the Hardy are indicative, however, of the two periods in which most of the photographs in this book were made: the mid-to-late nineteenth century, and the 1970s to the present. The comparatively sparse representation of work from the first three quarters of the twentieth century can be accounted for in part by the relative dormancy of the V&A's photographic collecting during this period. But the main reason for the dominance of early and recent work is that staged photography had a long hiatus once modernist ideas, which prioritized photography's unique ability to record the world, took hold in the early twentieth century. Whereas photographers had once indicated their artistic ambitions by making photographs that looked like paintings, by the 1920s they were asserting their creative vision by making pictures that were only possible with a camera. Imitating other art forms was anathema to modernist photographers.

Photographic fictions did persist in the contexts of fashion and advertising, however, and — in the form of moving images — in cinema. Between the wars, the Surrealists were not afraid of combining photographic fact and fiction. Their influence is clear in the work of Angus McBean (pp.132–3), who built elaborate sets in which to photograph his subjects, and in that of Philippe Halsman, who collaborated extensively with

Salvador Dalí (pp.134–5). Madame Yevonde also introduced fanciful elements into her photographs, using costumes, make-up, props and lighting, which transformed portrait sittings into performances (p.21). Other studio photographers, such as Gertrude Käsebier and Rosalind Maingot, used the conceit of two sitters looking at the same book or letter to inject a sense of action and narrative into otherwise straightforward portraits (pp.120–21).

Today, staged photography is an international phenomenon. While this selection includes contemporary artists from Brazil, Canada, China, Germany, Iran and the USA, more than half the photographers in the book are British. Not surprisingly, the V&A collection is particularly strong in British photography. Furthermore, staged photography was especially prevalent in nineteenth-century Britain, where it was practised alongside other popular social activities, such as fancy-dress and the performance of tableaux vivants and amateur theatricals. These pursuits offered similar opportunities not only to act out dramatic scenes but also to masquerade as members of other nationalities and social classes. This aspect of 'making it up' is evident, for example, in Oxford don Charles Lutwidge Dodgson's (aka Lewis Carroll's) photographs of an English girl dressed as a Chinese tea merchant (pp.156–7) and Welsh industrialist Robert Thompson Crawshay's portrayal of his daughter as a fishwife (p.159).

This is a book of stories told in pictures. From Little Red Riding Hood to Medusa, from Sleeping Beauty to King Arthur, subjects are drawn from myth, legend, fairy tales, novels, poems and plays. Photographic fictions are not limited to fictional subject matter, however. The imprisoned Mary, Queen of Scots was photographed in three dimensions in the 1860s (pp.64–5), and the medieval Queen Philippa and King Edward III posed for the camera in the 1870s (p.67). Contemporary practitioners, meanwhile, have staged the more recent past of their own lifetimes: Jo Spence photographed herself dressed as her mother (pp.110–11), and Trish Morrissey enacted scenes from her own childhood (p.118).

All the scenarios in this book were staged expressly for the purpose of being photographed; they do not document actual performances for audiences. Nonetheless, theatricality abounds, and many figures appear as though they were actors on a stage, framed by curtains as in O.G. Rejlander's *Two Ways of Life* (pp.94–5) and Henry Peach Robinson's *Fading Away* (pp.124–5). Curiously, the photographs of professional performers, such as the actress Yvonne Arnaud (p.63) and the opera singers Giulia Grisi and Giovanni Mario (p.60), are less fully realized than many of the other staged scenes. Arnaud's impressive Shakespearean costume upstages the actress herself, and the leafless potted plant between Grisi and Mario, dressed for a Verdi opera, grounds them in reality. In Julia Margaret Cameron's *The Minstrel Group*, however, while the costumes are makeshift, and the mandolin has no sound holes so could not be played in real life, the photograph as a whole offers a more complete imaginary world (p.61). Like many other proponents of staged photography, Cameron used her camera to conjure a fictional world rather than record a real one.

The visual arts are an even richer source of inspiration for photographic fictions than the literary or performing arts. Makers as diverse as Julia Margaret Cameron, Tom Hunter and Wang Qingsong have produced photographic versions of specific paintings by Raphael, Vermeer and the tenth-century Chinese scroll painter

Gu Hongzhong, respectively (pp.72, 85 and 96–7). Hunter's *Woman Reading a Possession Order* is unabashedly contemporary, yet the reference to Vermeer is clear. About eighty years earlier, Richard Polak took a more literal approach to recreating Dutch Golden Age paintings, meticulously populating his photographs with historic costumes and furnishings (pp.78–9 and 82–3). Printed in platinum, their cool tonal range suits the clarity of the paintings they imitate.

Some photographs refer more broadly to certain genres of painting, such as David Wilkie Wynfield's bust-length portraits of his Victorian contemporaries in medieval and Renaissance costume (pp.76–7), or Cindy Sherman's eighteenth-century-style portrait, fashioned in the 1980s (p.81). Julia Margaret Cameron and Emma Barton each photographed numerous Renaissance Madonnas (pp.73 and 75). In depictions of religious subjects such as these, as well as in F. Holland Day's series of himself as Christ (p.89), the literal here-and-nowness of photography contrasts particularly strongly with abstract, spiritual concepts.

In two very different series, Yinka Shonibare MBE and Andy Wiener cast themselves in their own versions of Hogarth's *A Rake's Progress*. While Wiener transfers the story from the 1730s to the 1980s, replacing each character's face with a mask of his own (pp.102–3), Shonibare imagines himself as a black Victorian dandy at the centre of increasingly debauched scenes (pp.99–101). The large-scale photographs, complete with fake gold frames, imitate paintings in their format as well as content. Jeff Wall and Gregory Crewdson (pp.22–3 and 24–5) also produce very large photographs (although the Wall in this book happens to be a small print). When viewed in person, such photographs compete with paintings in terms of impact and scale.

At an entirely different scale, stereographs also deliver an immersive experience. Stereo cards are small enough to be held in the hand, but when seen through a stereoscope – a device that was found in many Victorian homes – they fill the spectator's field of vision (pp.31, 64–5, 69, 93, 141–4 and 167). Other small, staged photographs meant to be viewed in domestic settings and on social occasions were pasted into albums, such as those kept by the Dillwyn Llewelyn family in the 1850s (pp.36 and 49) or the now lost albums in which Lady Hawarden's photographs were once presented (pp.114–17).

The family album is itself a point of reference for some photographers. Trish Morrissey, in recreating snapshots from her childhood, highlights the role of photography in shaping family narrative. Maxine Walker also enacts alternate versions of herself in front of the camera. She imitates another familiar photographic format, the photo-booth portrait, in her exploration of racial identity (pp.108–9), while Jan Wenzel constructs scenes inside an actual photo booth, laying the strips together to create a complete image (p.169). Some photographs refer to the medium by staging the contexts in which certain types of photographs are made, from photojournalism to fashion and celebrity photography (see John A. Walker and Carolyn Davies, p.147; and Richard Avedon, pp.148–9). Others recreate well-known photographs at a vastly different scale from the original, as in Terry Towery's table-top diorama of Roger Fenton's Crimean War landscape (p.175), or from unexpected materials, such as Vik Muniz's chocolate-syrup rendering of a photograph of Jackson Pollock action-painting (p.136).

There is a playfulness to many such self-referential photographs, and indeed staged photography more generally. In the nineteenth century, Rejlander joked in front of the camera with works such as *First I Lost My Pen and Now I've Lost My Spectacles* and *O.G.R. the Artist Introduces O.G.R. the Volunteer* (pp.39 and 105). Comic subjects were also popular in mass-produced stereographs (see pp.141–4). Today, Vik Muniz and William Wegman excel at visual and verbal punning (pp.136 and 138), as did Keith Arnatt, who created a whole series of picturesque 'canned sunsets' out of discarded tin cans (p.176). Tess Hurrell also uses everyday materials, such as cotton wool, thread and talcum powder, to evoke a large-scale phenomenon (p.177). These artists are tricksters who want to be found out.

The individuals behind such unpopulated, constructed scenes assert their presence as makers of models and arrangers of objects. For many artists, however, staged photography offers an opportunity to insert themselves more directly in the picture. For Xing Danwen this means digitally stitching images of herself into photographs of architectural models (p.178) and for Wang Qingsong, casting himself as an observer in a series of crowded tableaux (pp.96–7). Others play starring roles, revealing their bodies – from F. Holland Day as a crucified Christ to Pierre Molinier's erotic self-portraits (pp.89–91) – or transforming their faces, as in Maxine Walker's twist on ID photography. There are numerous other instances of self-depiction, the most well-known by Cindy Sherman, who has spent her career turning her camera on herself in a wide array of guises, many of which refer to the roles women play in contemporary society and popular culture (pp.150–51).

As the following selection demonstrates, in every decade since photography's invention, photographers all over the world have been inventing characters and stories in front of the camera, combining the apparent truthfulness of photography with their imaginations. Critics of staged or narrative photography have argued that photography's inherent realism interferes with, or even undermines, any attempt to use the medium to tell stories or evoke the imaginary. But it is in part that very realism that makes photographic fictions so compelling.

Marta Weiss
Curator, Photographs
Victoria and Albert Museum, London

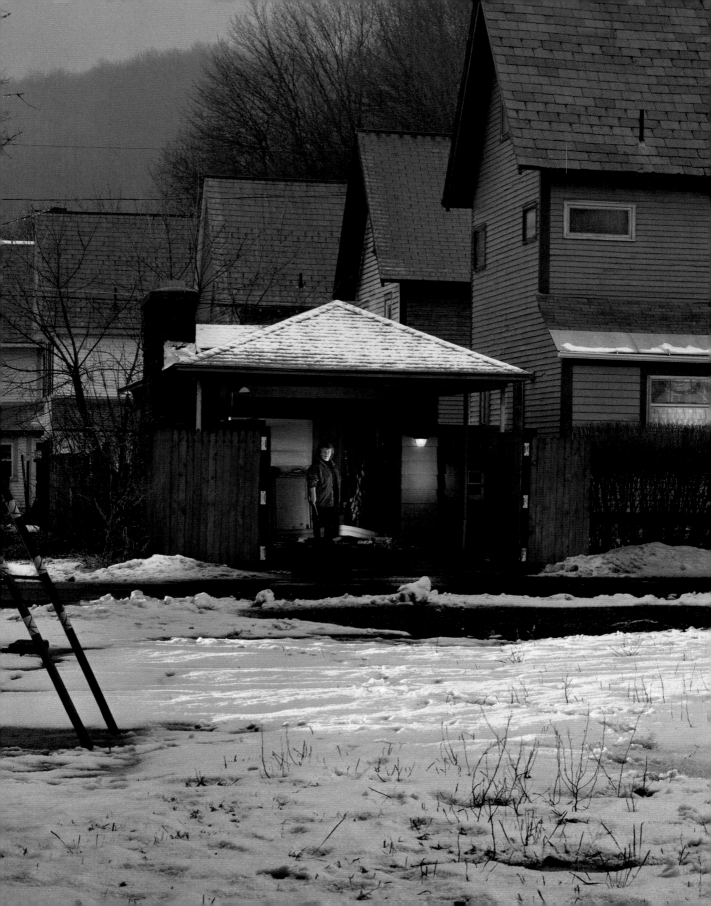

Plates

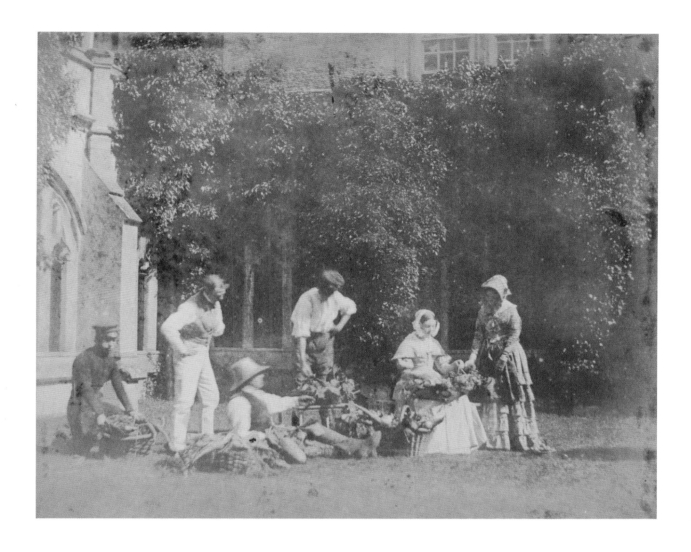

Attributed to
William Henry Fox Talbot (1800–1877)
and Calvert Richard Jones (1802–1877)

The Fruit Sellers
1845

Salted paper print
17.2 x 21 cm

Soon after announcing his invention of the calotype, or paper negative, process, Talbot noted that 'when a group of persons has been artistically arranged, and trained by a little practice to maintain an absolute immobility for a few seconds of time, very delightful pictures are easily obtained'. The members of this group were not actually selling fruit but were probably domestic staff arranged by fellow-photographer Calvert Richard Jones on the grounds of Talbot's estate, Lacock Abbey.

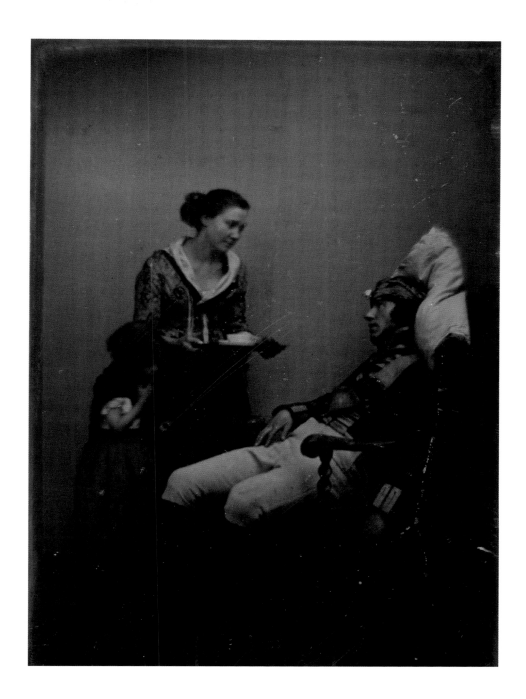

Unknown photographer

Wounded soldier
1842

Daguerreotype
9 x 6.5 cm

The invention of the daguerreotype was announced in France in 1839. Almost immediately, it was employed to record not only the likenesses of people and places, but also staged scenarios suggestive of narrative. This sentimental depiction of a woman and child tending to a wounded soldier was most likely set up in a British daguerreotypist's studio.

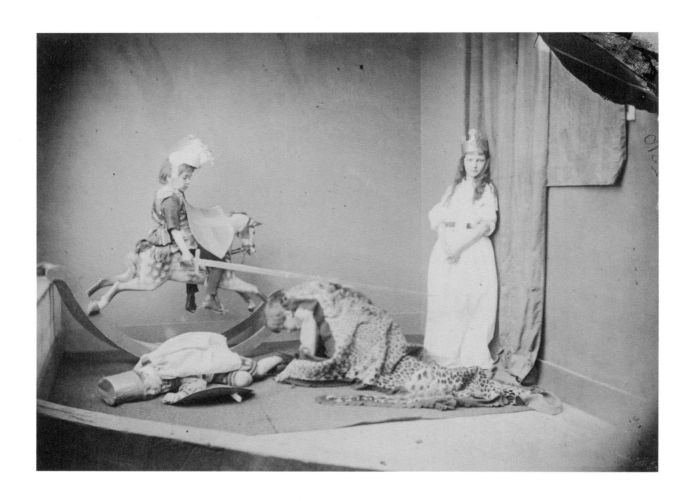

Charles Lutwidge Dodgson
(aka Lewis Carroll) (1832–1898)

St George and the Dragon
1875

Albumen print
9.8 x 13.4 cm

Best known as the author of *Alice's Adventures in Wonderland*, Dodgson was also an Oxford mathematics don and an accomplished amateur photographer. Many of his photographs are portraits of his 'child friends'. Here, four siblings enact St George slaying the dragon and rescuing the princess. The scene is at once a depiction of the popular legend and a staged representation of children at play.

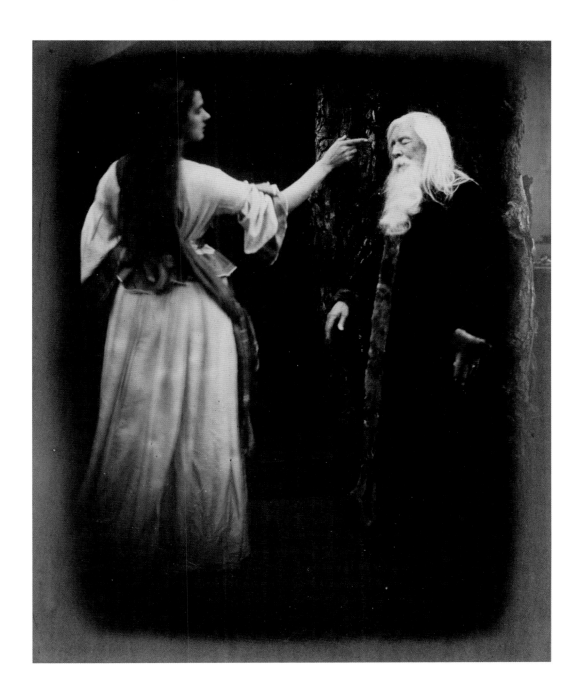

Julia Margaret Cameron (1815–1879)

Vivien and Merlin
1874

Albumen print
32 x 26.5 cm

Cameron produced two volumes of illustrations to *Idylls of the King*, Alfred Tennyson's cycle of narrative poems based on the legends of King Arthur. Here the sorceress Vivien, played by Agnes Mangles, casts a spell over the wizard Merlin, enacted by Cameron's husband Charles. Mangles later wrote that Charles could not stop chuckling during the theatrically posed sitting, thus spoiling many negatives.

Madame Yevonde (1893–1975)

Mrs Mayer as Medusa
1935

Tri-colour carbro print
36.2 x 29.6 cm

A fashionable London portrait photographer, Yevonde made innovative use of the newly available Vivex colour process. This striking image belongs to her series of 'goddess' portraits of society women. Medusa's face is framed by her snake-hair, and her steady stare threatens to turn the viewer to stone. Yet it is Medusa herself — or more literally Mrs Mayer — who has been frozen by the camera.

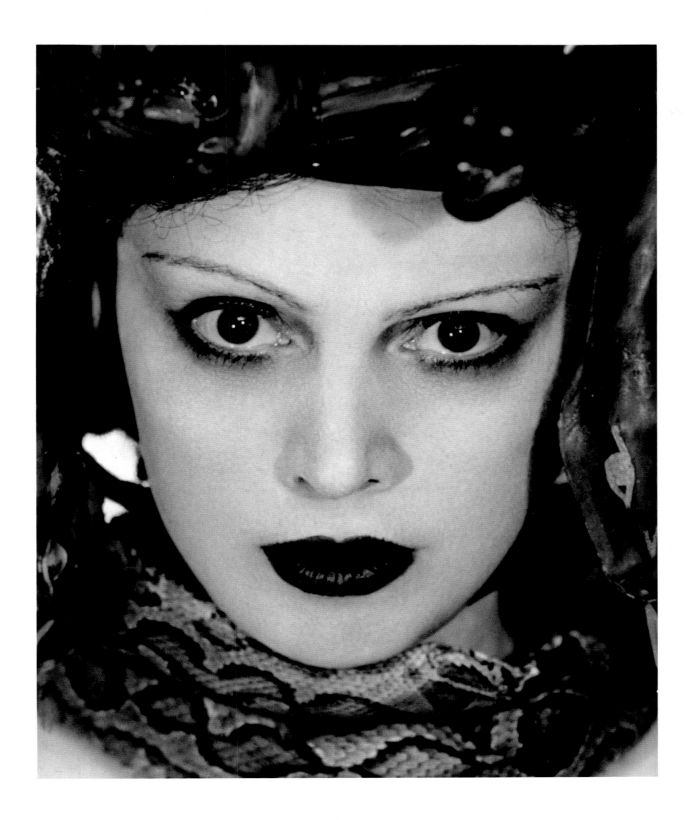

Jeff Wall (b.1946)

The Outburst
from the portfolio *In a Dream You Saw a Way to Survive and You Were Full of Joy*
1989

Dye destruction print
45.8 x 61.5 cm

Wall is one of the most influential practitioners of contemporary tableau photography. This often involves directing actors on an elaborately constructed set in the manner of a film production. The central figure in this staged scene is captured at the climax of a confrontation. The viewer is left to imagine the story behind this emotionally charged moment.

Gregory Crewdson (b.1962)

Untitled
2006

Digital pigment print
144.8 x 223.5 cm

(detail p.12)

Crewdson works on an epic scale with actors and a large crew. He turns an average suburb into a stage set for what he calls 'frozen moments': inexplicable, sometimes disturbing events that often take place at twilight. Crewdson draws on the mythology of small-town America to evoke the loneliness of an Edward Hopper painting and the foreboding of a Hitchcock film.

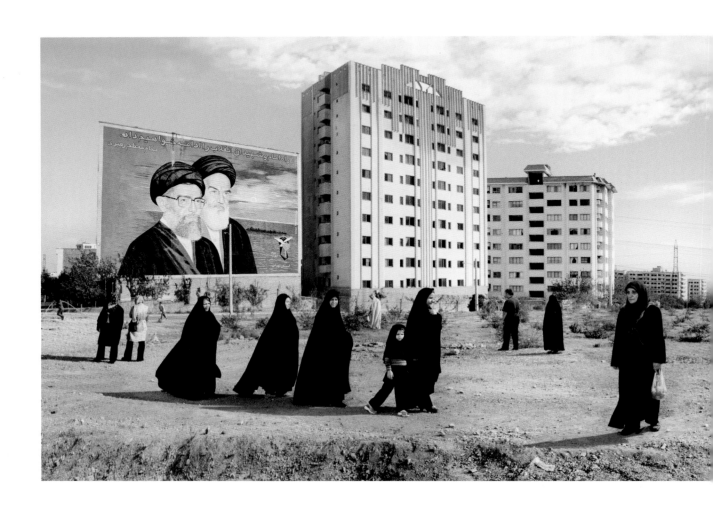

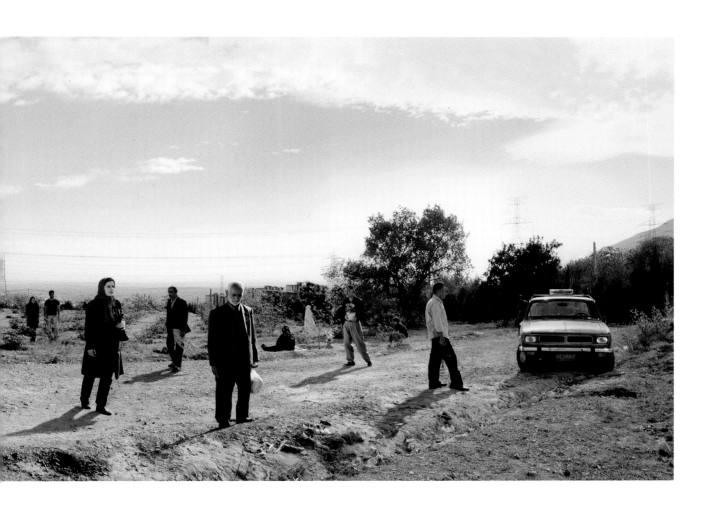

Mitra Tabrizian (b.1956)

Tehran 2006
2006

Digital C-type print
101 x 302 cm

Tabrizian engages non-professional models to play themselves in carefully staged scenes. She photographs them all at once, without digital manipulation. Here a disparate group of citizens appear to go about their everyday business in a residential area on the outskirts of Tehran. A metaphorical exploration of isolation and exile, the image also reflects a nation with mounting ideological and religious tensions.

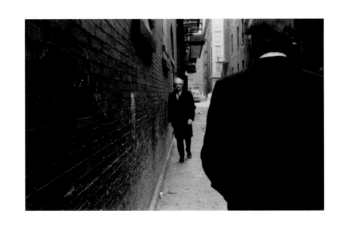

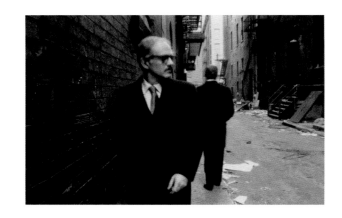

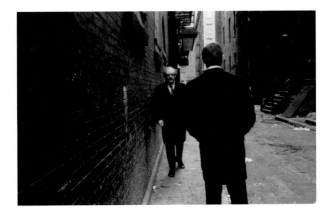

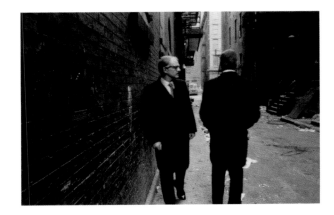

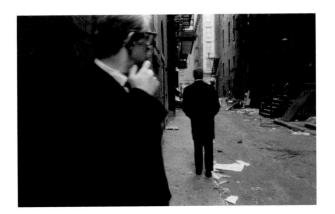

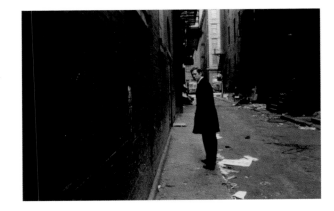

Duane Michals (b.1932)

Chance Meeting
1972

Gelatin silver prints
8.5 x 12.8 cm each

Michals uses sequences of photographs to suggest
a narrative. The stories are often open-ended,
and sometimes even surreal. In this sequence,
two men pass in an alleyway without incident,
but the encounter seems loaded with significance.
The photographs are framed consistently, and the
figures move in and out of the shot, as in a film.

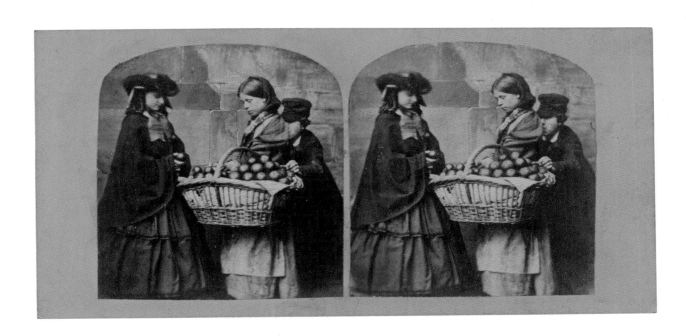

Unknown photographer

Untitled
*c.*1860

Stereograph
8.3 x 17.2 cm

A stereograph is a pair of photographic images
of the same subject taken from slightly different
angles. The illusion of a three-dimensional image
is created when a stereograph is viewed through a
stereoscope. This optical device occupied a place
in the drawing room, as a television might today,
providing entertainment that was both amusing and
instructive. Stereographs were the most popular
outlet for staged and narrative photography in the
nineteenth century.

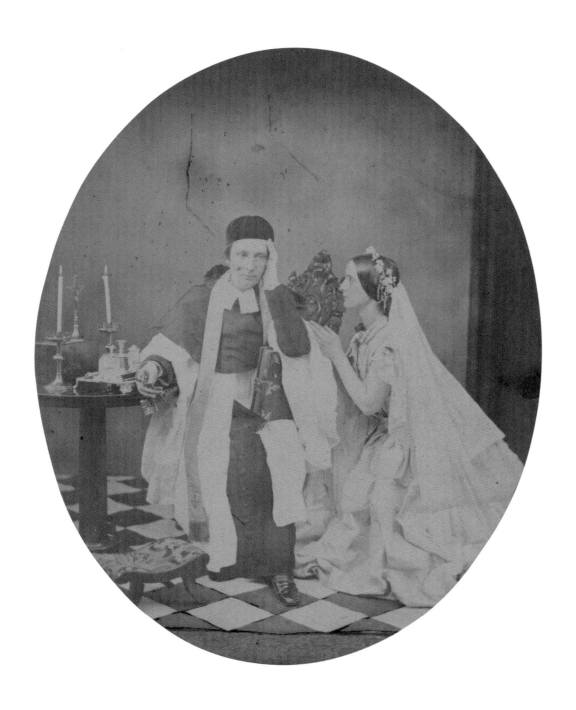

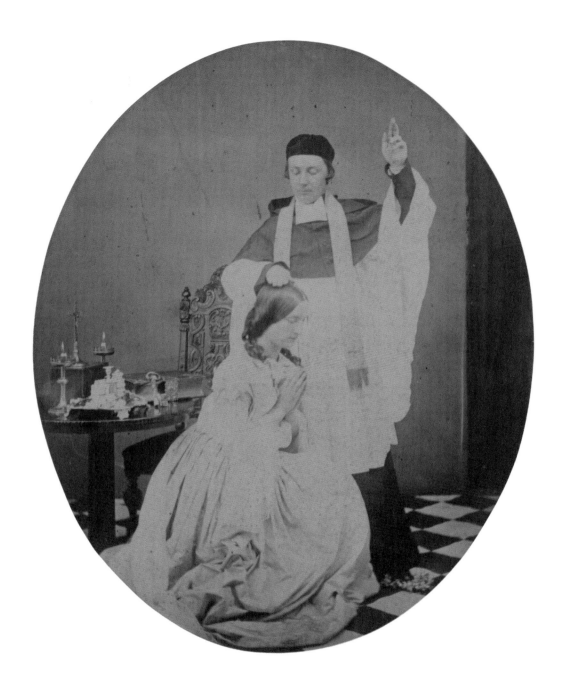

William Mayland (1821–1907)

Untitled
*c.*1860

Albumen prints
13.6 x 10.7 cm

In this pair of tableaux, a priest hears confession from a young woman, then grants her absolution. The strip of carpet in the foreground of the first image reveals the studio setting in which the scenes were staged. A pair of lit candles standing among the props on the table indicate the passage of time, having burnt down from one picture to the next.

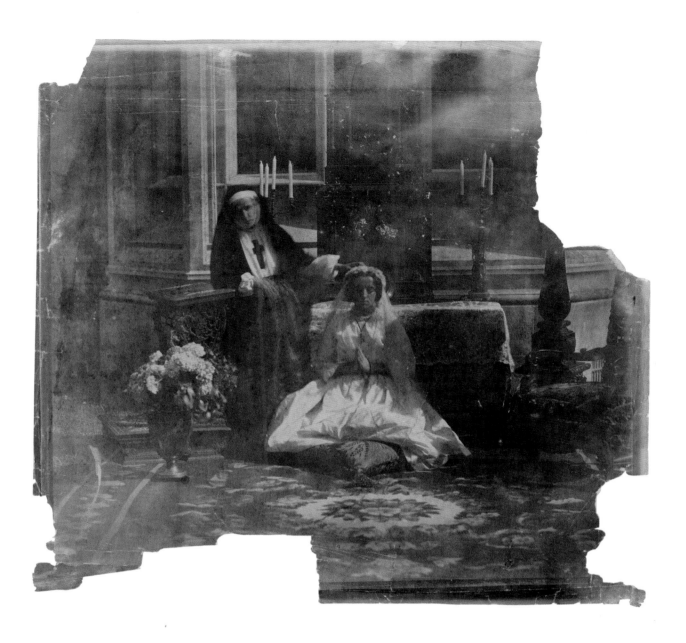

Unknown photographer

Untitled
1850s

Salted paper print
39.5 x 41.5 cm

This photograph shows a young woman dressed
in the traditional bride's costume worn for
initiation into a Christian religious order.
The setting is presumably meant to suggest the
interior of a chapel, but is actually outside. This
is probably because a substantial amount of light
would have been required for the exposure of the
large negative, which would have been at least as
big as the print itself.

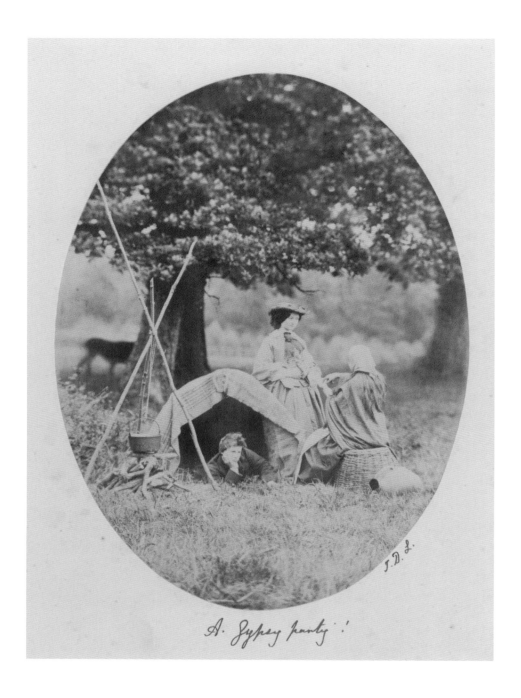

A. Gypsy party .·

John Dillwyn Llewelyn (1810–1882)

A Gypsy Party
c.1853

Salted paper print
20.4 x 15.2 cm

Many nineteenth-century amateur staged photographs feature members of the upper classes play-acting at positions of lower social status. The models in this scene are the photographer's children. One girl reads the other's palm, while the boy reclines next to a fake campfire. Llewelyn learned about photography from his cousin-in-law, William Henry Fox Talbot, inventor of the calotype, or paper negative, process.

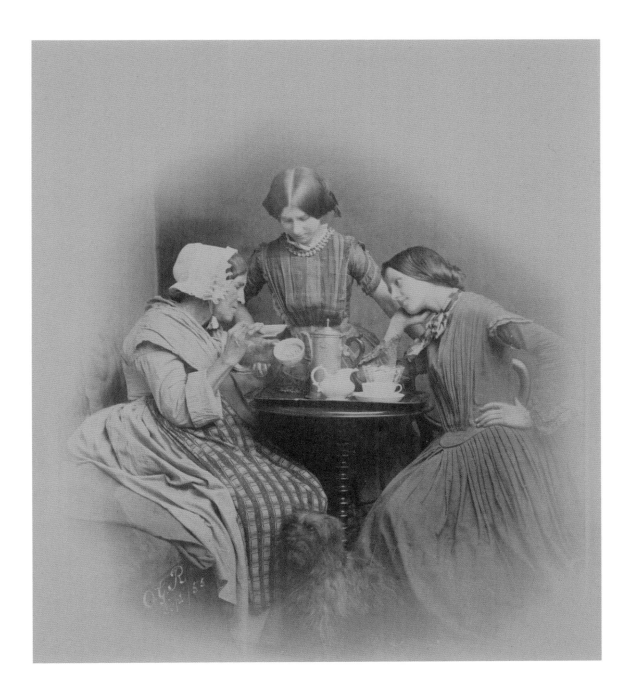

O.G. Rejlander (1813–1875)

Fortune-telling
1855

Albumen print
21.9 x 19.3 cm

Two young women watch attentively as an older woman reads a fortune in tea leaves at the bottom of a cup. Rejlander inked the leaves onto the photograph to make them more apparent. The vignetting around the group helps distance them from the studio in which they posed. Rejlander's signature, which he added by painting his initials onto the negative, attests to his artistic ambitions for photography.

O.G. Rejlander (1813–1875)

First I Lost My Pen and Now I've Lost My Spectacles
c.1860

Albumen print
23.1 x 22 cm

Rejlander often introduced humour into his staged photographs, and this is one of his more light-hearted subjects. The woman (possibly Rejlander's wife Mary) peeking mischievously from behind a curtain makes the picture's theatricality plain.

I

Frances Kearney (b.1970)

Five People Thinking the Same Thing
I, II, III, IV and *V*
1998

C-type prints
approx. 123 x 153 cm each

Kearney's images seem to be spontaneous snapshots but are in fact meticulously staged. Clothes, expressions and posture are all contrived for the photograph, and scenes are reworked until a sense of stillness is achieved. Kearney's figures convey a monumental and meditative quality, absorbed in what she has described as 'lost time'. They are caught at a moment of personal reflection, perhaps waiting for something to happen.

//

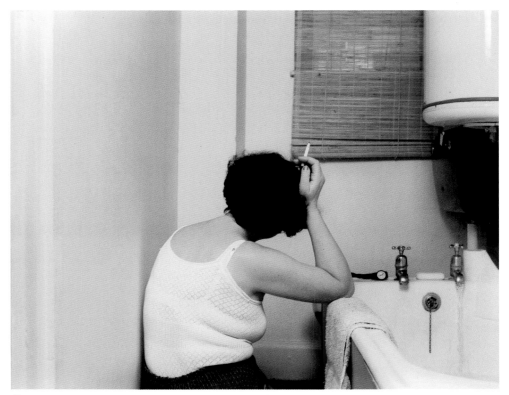

///

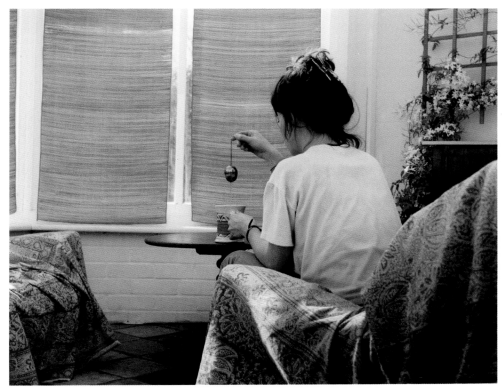

IV

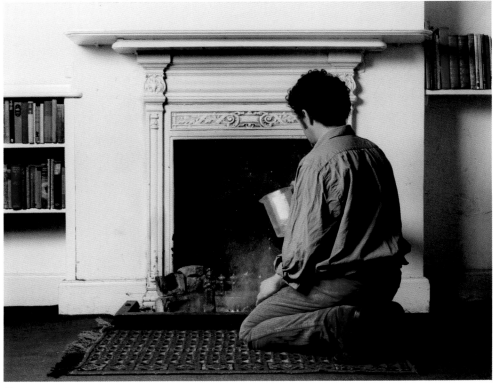

V

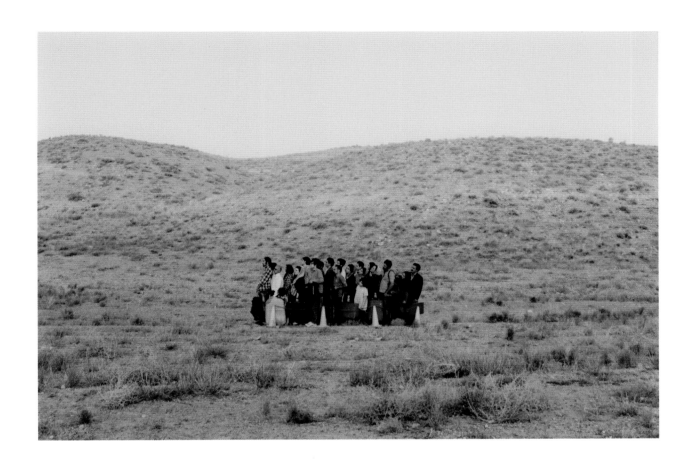

Gohar Dashti (b.1980)

Iran, Untitled
2014

Archival inkjet print
16.2 x 24.1 cm

In the centre of a vast desert landscape a group of figures clusters tightly in a queue. Baggage in hand, they seem to await anxiously a voyage that will never begin. A story is implied, but not revealed. Only a sense of futility is clear.

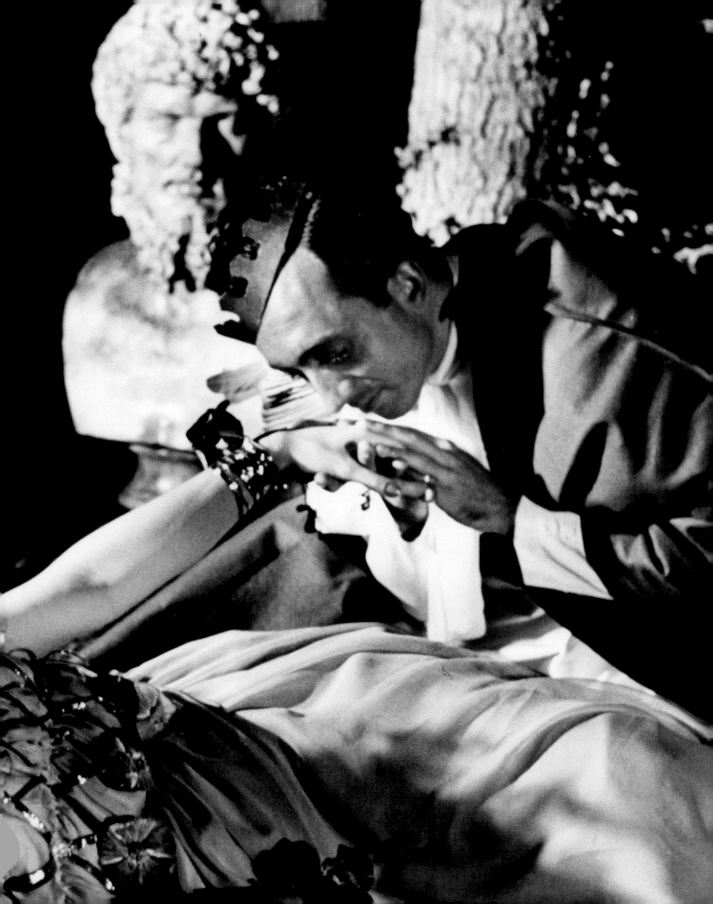

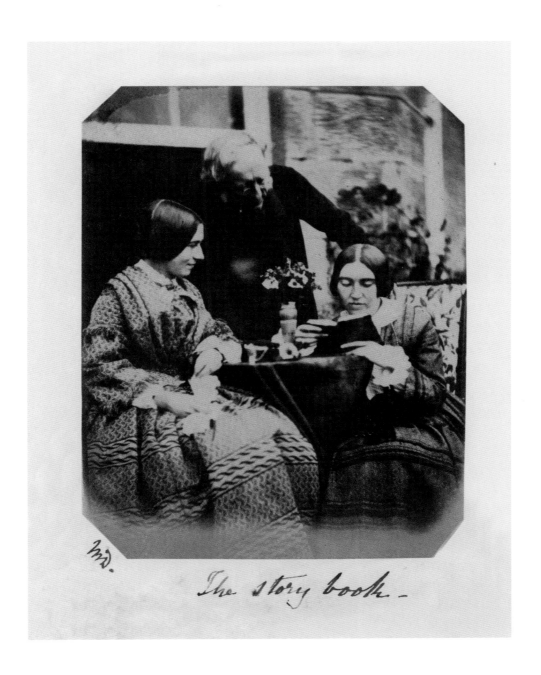

The story book

Mary Dillwyn (1816–1906)

The Story Book
c.1853

Salted paper print
10.9 x 8.5 cm

Dillwyn was the first woman photographer in Wales and the sister of pioneering photographer John Dillwyn Llewelyn, who also arranged friends and family into narrative scenes for the camera. The sitters in this composition appear remarkably natural. The photograph was pasted into an album, which might be considered a visual story book.

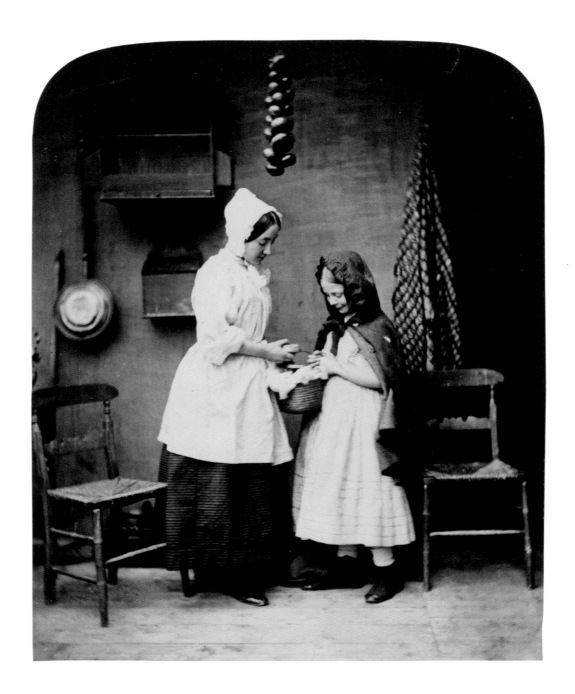

Henry Peach Robinson (1830–1901)

The Story of Ridinghood
1858

Albumen prints
50 24.3 x 19.3 cm
51 24.3 x 17.8 cm
52 24.5 x 19.7 cm
53 24.9 x 19.1 cm

Robinson illustrated the story of Little Red Riding Hood in four scenes. When he exhibited the series in 1858, some critics were charmed but one wrote sarcastically that the photographs proved the truthfulness of the famous story and expressed amazement that Robinson had been alive since 'once upon a time'.

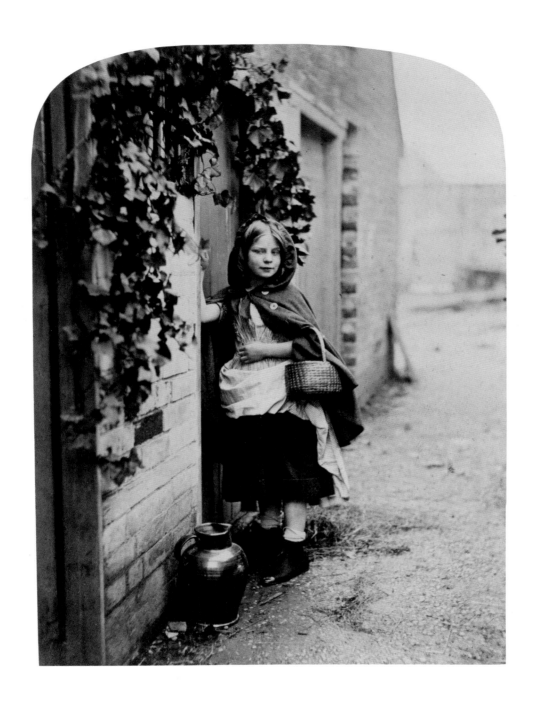

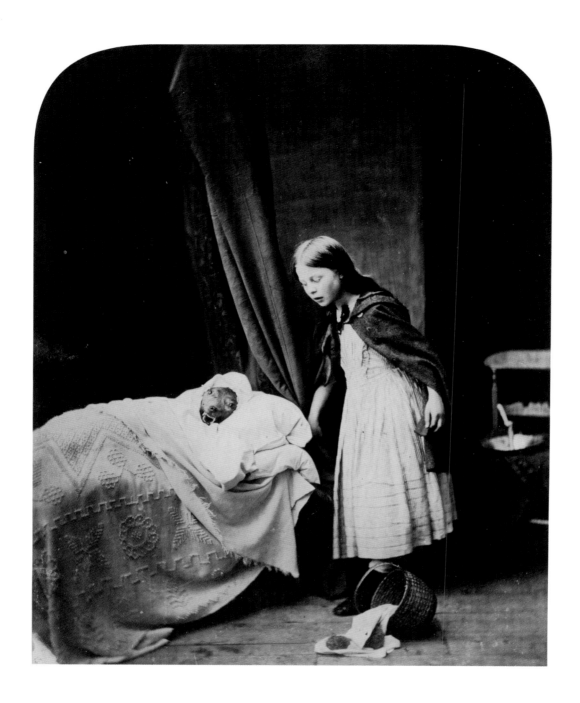

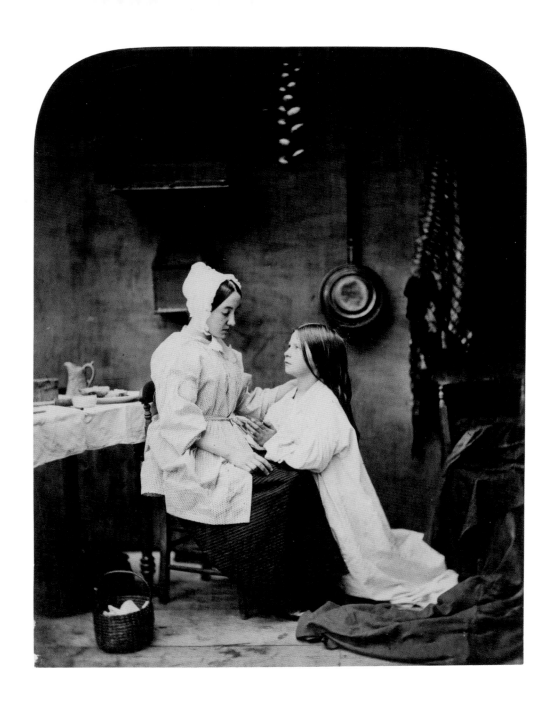

Julia Margaret Cameron (1815–1879)

Paul and Virginia
1864

Albumen print
26.6 x 21.5 cm

Cameron made several variations on this scene from Jacques-Henri Bernardin de Saint-Pierre's tragic romance *Paul et Virginie* (1787). The novel tells of the ill-fated love of two children (here played by Freddy Gould and Elizabeth Keown) living on Mauritius. The image depicts the passage in which the two are caught in a storm. Cameron was most satisfied with this version and made multiple prints of it. Yet she still found fault with Paul's feet, and scratched into the negative to make them appear slimmer.

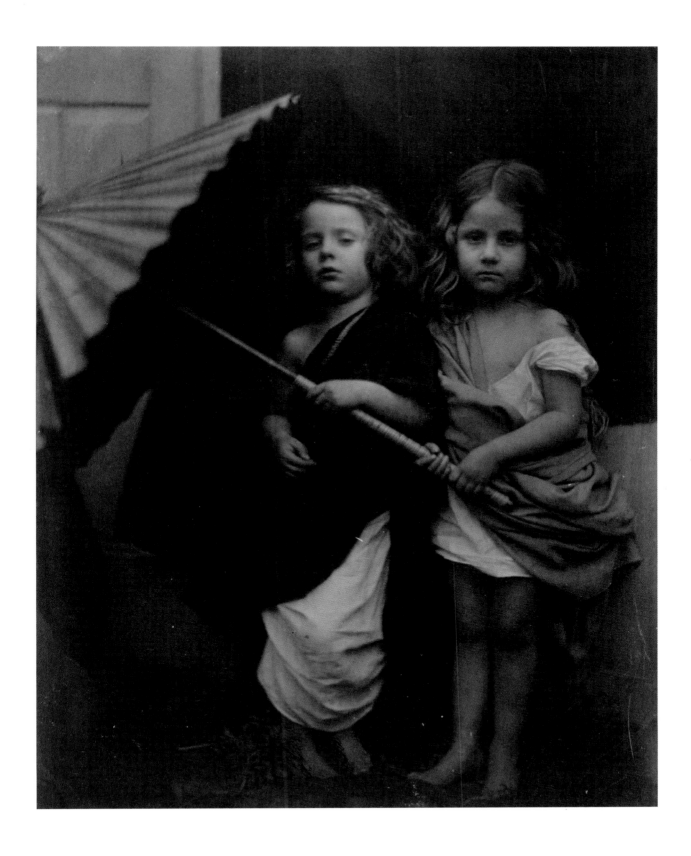

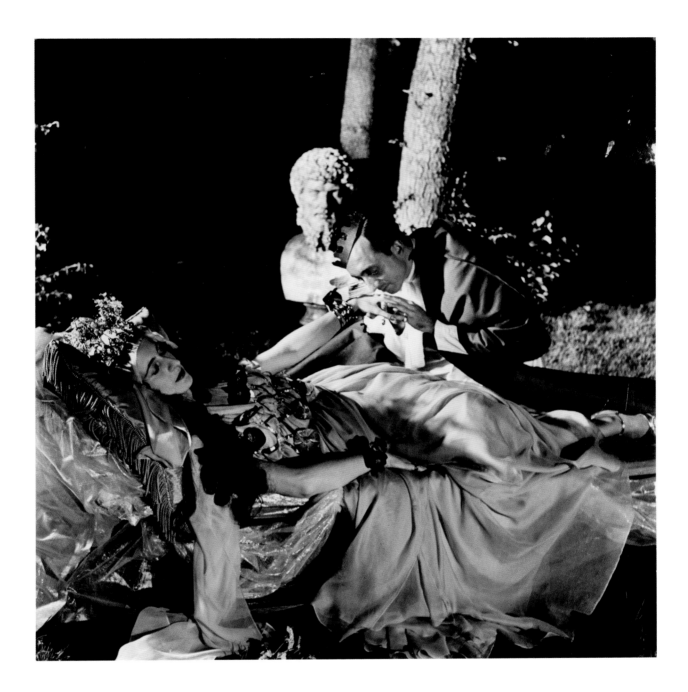

Roger Schall (1904–1995)

*Au bal de la forêt à Durst et la belle
au bois dormant*

[Durst's Forest Ball and Sleeping Beauty]
1939

Gelatin silver print
31.5 x 30.3 cm

(detail p.47)

These guests at a fancy-dress ball enact a scene
from 'Sleeping Beauty'. Although costumed for a
social event, they posed theatrically to be recorded
by the camera. The lavish, forest-themed ball,
hosted by *Vogue* photographer André Durst,
was one of many such inter-war gatherings that
attracted socialites and members of the Parisian
fashion world.

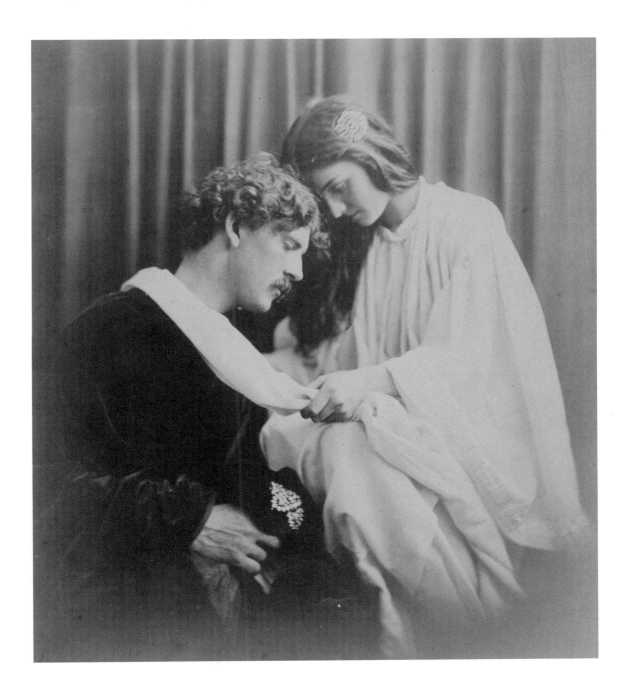

Julia Margaret Cameron (1815–1879)

Sordello
1867

Albumen print
50.5 x 39.2 cm

Cameron's maid Mary Ryan and Henry John Stedman Cotton, a member of the Indian Civil Service, were married in 1867. Cameron was proud of the pair's cross-class romance and cast them together on several occasions. Here they play characters from a narrative poem by Robert Browning. Cameron inscribed a verse on one print, ending with the lines: '... she/Unbound a scarf and laid it heavily/Upon him, her neck's warmth and all.'

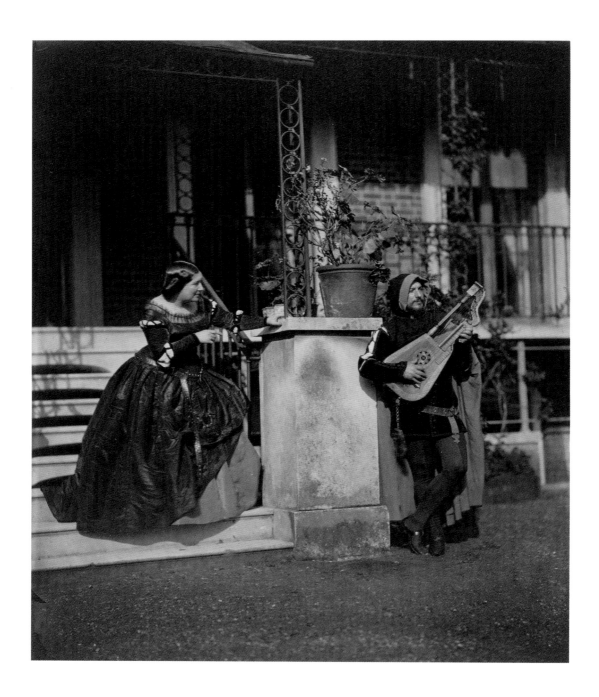

Leonida Caldesi (1822–1891)
and Mattia Montecchi (1816–1871)

The Serenade (Mario and Grisi in 'Il Trovatore')
c.1857

Albumen print
42.8 x 35.7 cm

Opera singers Giulia Grisi and Giovanni Mario
enact a scene from Verdi's *Il Trovatore* (*The
Troubadour*). Their costumes and contrived poses
are at odds with the ordinary Victorian garden
setting. The image was used to illustrate sheet
music, and was reproduced as a small, collectible,
carte-de-visite photograph, but this print was made
for display. In 1858 it was exhibited at the Victoria
and Albert Museum (then the South Kensington
Museum), to which it was bequeathed in 1868.

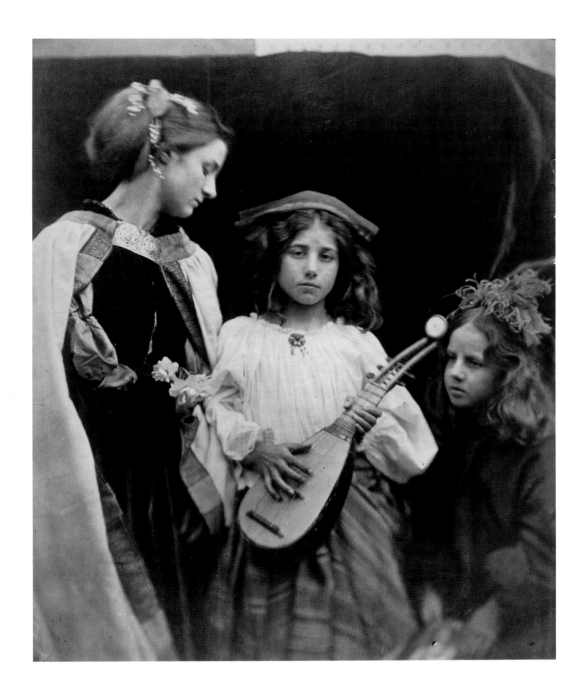

Julia Margaret Cameron (1815–1879)

The Minstrel Group
1866

Albumen print
34.5 x 28.5 cm

Cameron inscribed some copies of this photograph with lines from Christina Rossetti's 1862 poem *Advent*: 'We sing a slow contented song/and knock at Paradise.' The subject matter of the poem is religious, but Cameron emphasizes the musical association. The central minstrel, or travelling musician, is dressed in Italian peasant costume and holds a mandolin.

Walter Bird (1903–1969)

Yvonne Arnaud
1930s

Tri-colour carbro print
30 x 23.4 cm

The actress Yvonne Arnaud most likely wore this costume for her role as Katharine in a production of Shakespeare's *Henry V*, rather than for a scene staged expressly to be photographed. The rich greens of the fabric and vivid red of her lips are typical of the Vivex colour process, which Bird embraced in the 1930s.

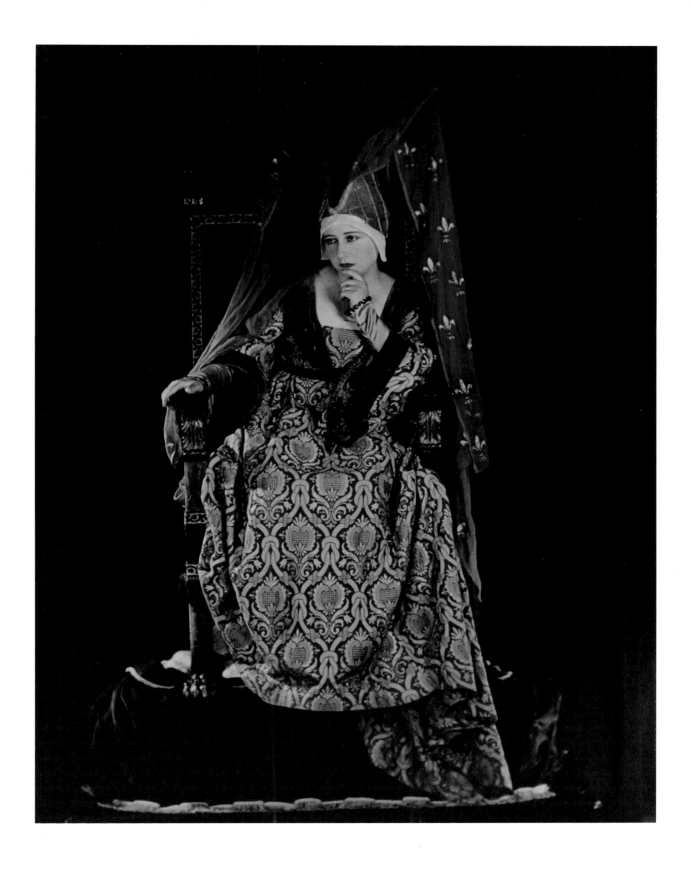

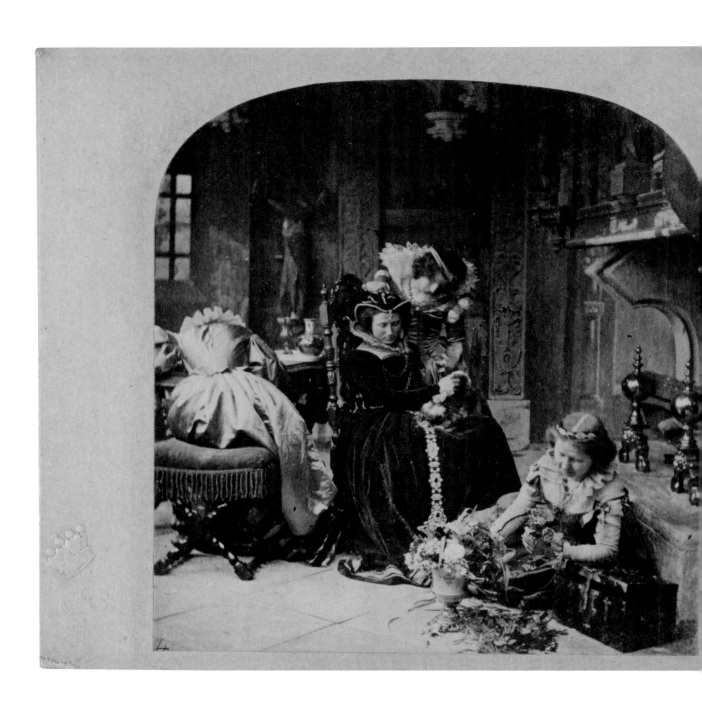

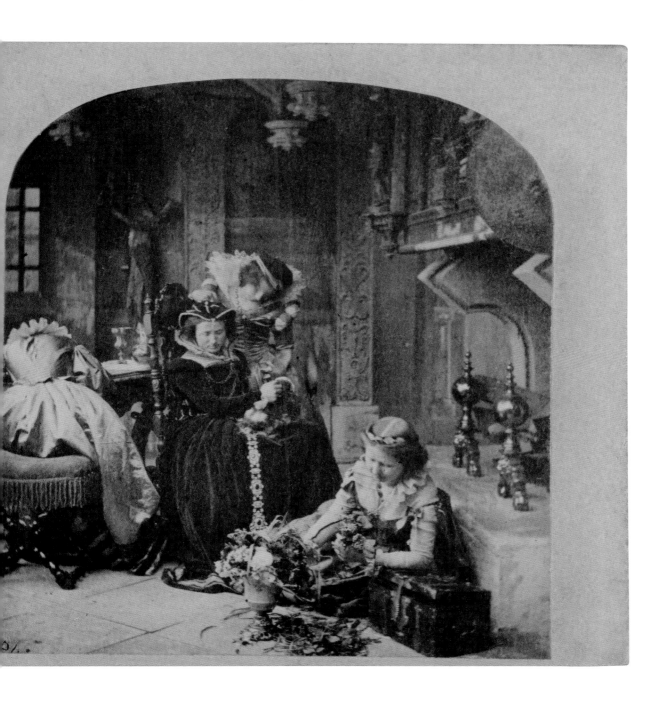

James Elliott (1835–1903)

Mary, Queen of Scots. A Prisoner
c.1860

Stereograph
8.5 x 17.4 cm

As in today's period dramas, the sets, props and costumes used to stage this moment from history would have transported viewers to another time and place. The experience would have been particularly immersive when seen in three dimensions through a stereoscope.

Julia Margaret Cameron (1815–1879)

Queen Philippa interceding for the Burghers of Calais
1872–4

Albumen print
48.2 x 39.8 cm

In this medieval scene, Queen Philippa begs her husband Edward III to spare the six leading citizens of Calais, who offered their lives in exchange for an end to the English siege. The large cast and fancy-dress costumes recall the amateur theatricals Cameron's family and friends enjoyed performing. At the far left is Henry Herschel Hay Cameron, the photographer's youngest son, who acted professionally before becoming a photographer himself. His brother Ewen plays the king.

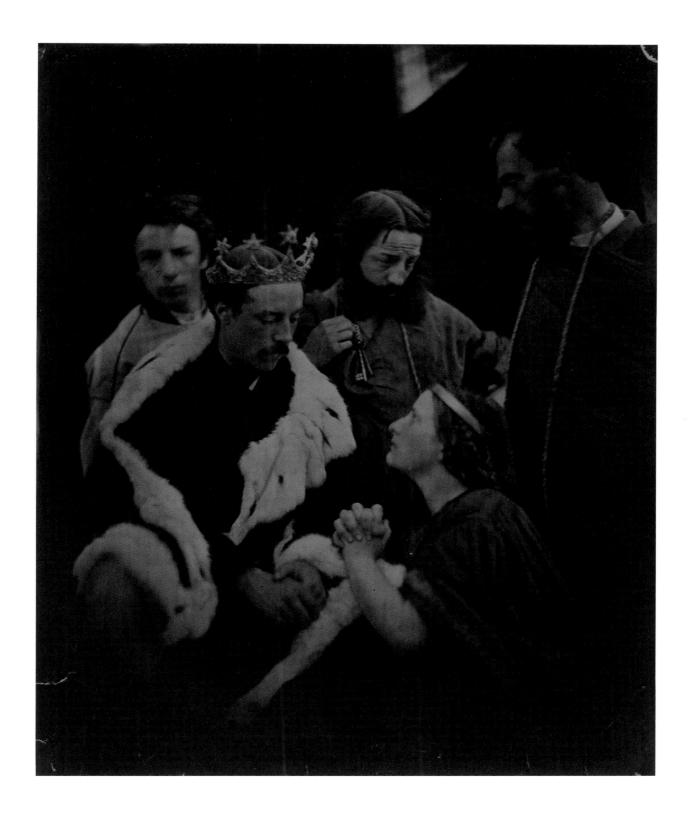

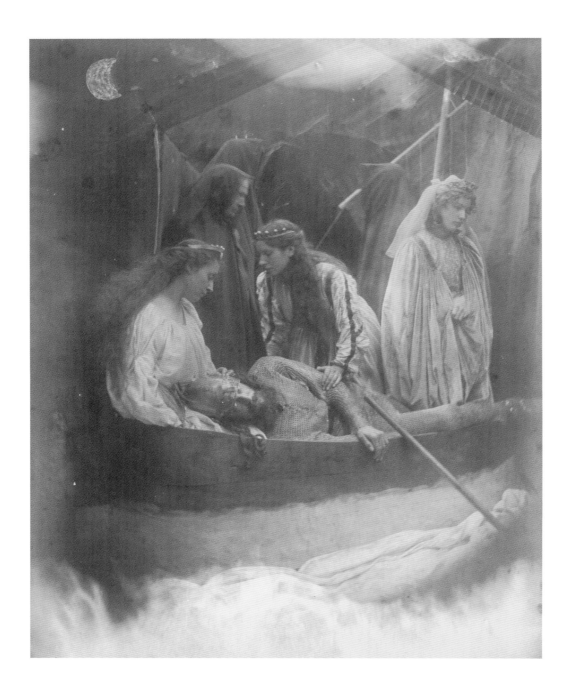

Julia Margaret Cameron (1815–1879)

The Passing of Arthur
*c.*1875

Albumen print
34 x 27 cm

In this episode from Tennyson's *Idylls of the King*, the wounded King Arthur is taken by boat from Camelot. Cameron employed more stagecraft than usual, creating the illusion of waves and mist out of fabric, and even drawing a moon on the negative in the upper left corner.

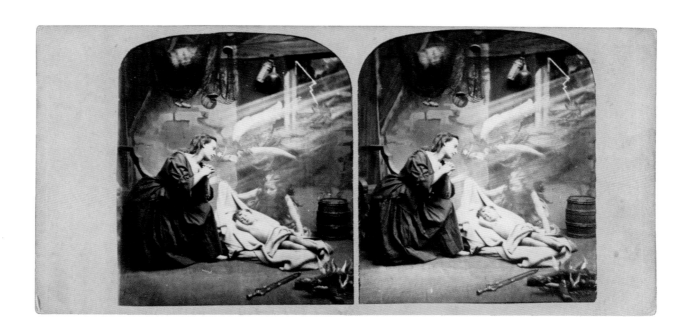

Attributed to
John Reynolds

The Angel's Whisper
c.1860

Stereograph
8.5 x 17.6 cm

A verse on the back of this stereo card tells the story of a fisherman's wife worried for his safety during a storm. She is reassured when her baby smiles in its sleep, a sign that 'angels are whispering' to her husband. The scene is realized through both staging and the special effects of retouching and multiple exposure.

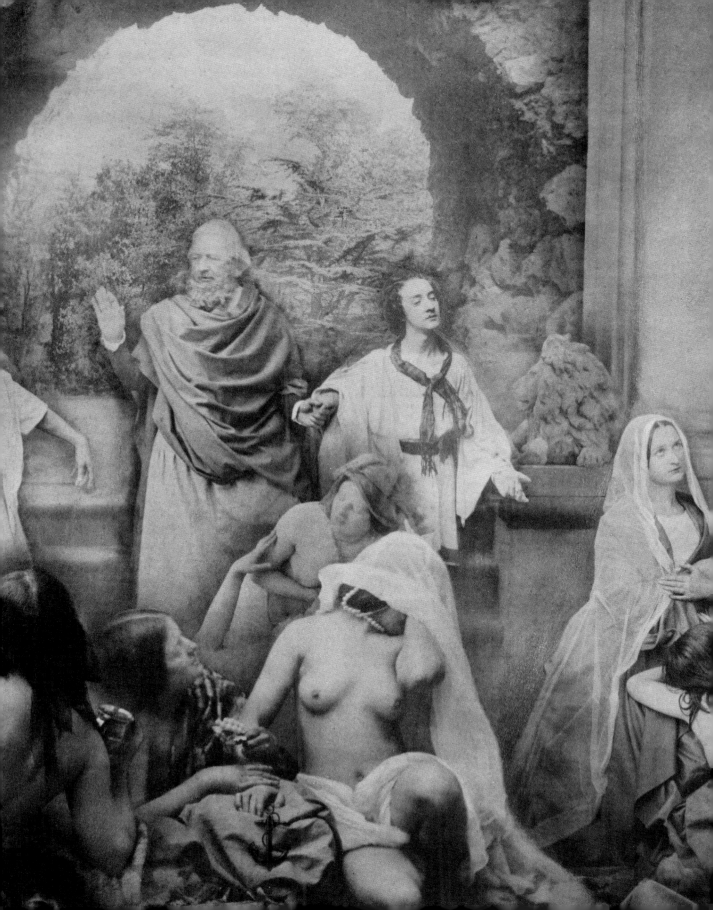

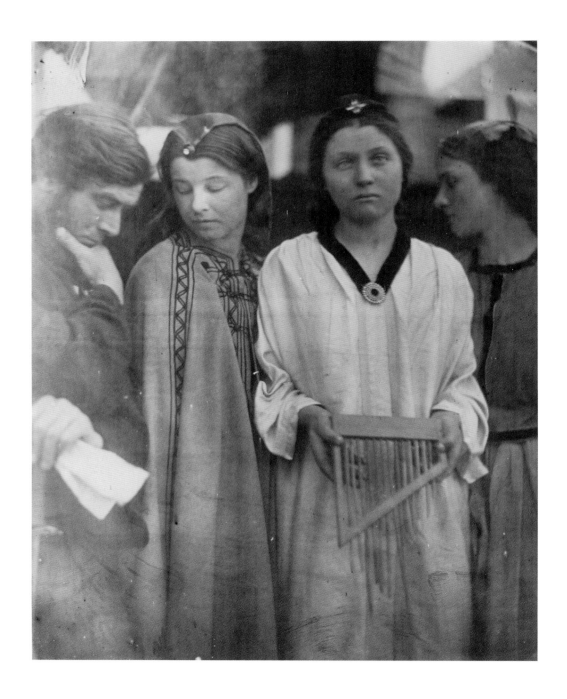

Julia Margaret Cameron (1815–1879)

St Cecilia, after the manner of Raphael
1864–5

Albumen print
25.4 x 20 cm

As Cameron endeavoured to make art photography, she looked to Renaissance painting for inspiration. She closely modelled this photograph on Raphael's painting *Ecstasy of St Cecilia*, depicting the patron saint of musicians. Raphael was particularly admired in Victorian Britain, and Cameron would have seen prints and possibly photographs of this work.

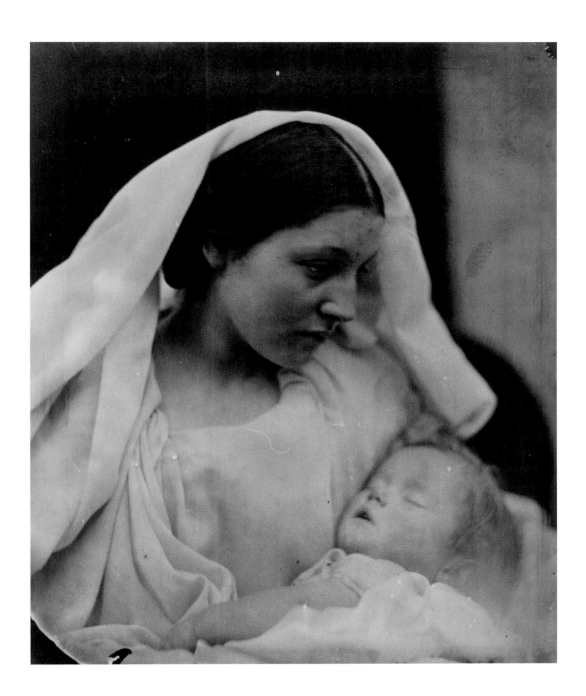

Julia Margaret Cameron (1815–1879)

La Madonna Riposata/Resting in Hope
1864

Albumen print
25.8 x 21.5 cm

A devout Christian and mother of six, Cameron returned to the motif of the Madonna and Child repeatedly. A sleeping child was less likely to move during the long exposure but was also suggestive of death, a grim reality for many Victorian families and a reference to the Pietà, a subject in Christian art in which the Virgin Mary cradles the dead Christ. Cameron's housemaid Mary Hillier posed as the Virgin Mary so often that she became known locally as 'Mary Madonna'.

Emma Barton (1872–1938)

The Awakening
1903

Carbon print
35.7 x 26.5 cm

Like many Pictorialist photographers, Barton found ideas for style, composition and subject matter in Old Master paintings. She made numerous Madonna and Child studies but considered *The Awakening* her 'best picture'. It was included in the British section of the St Louis International Exhibition in 1904.

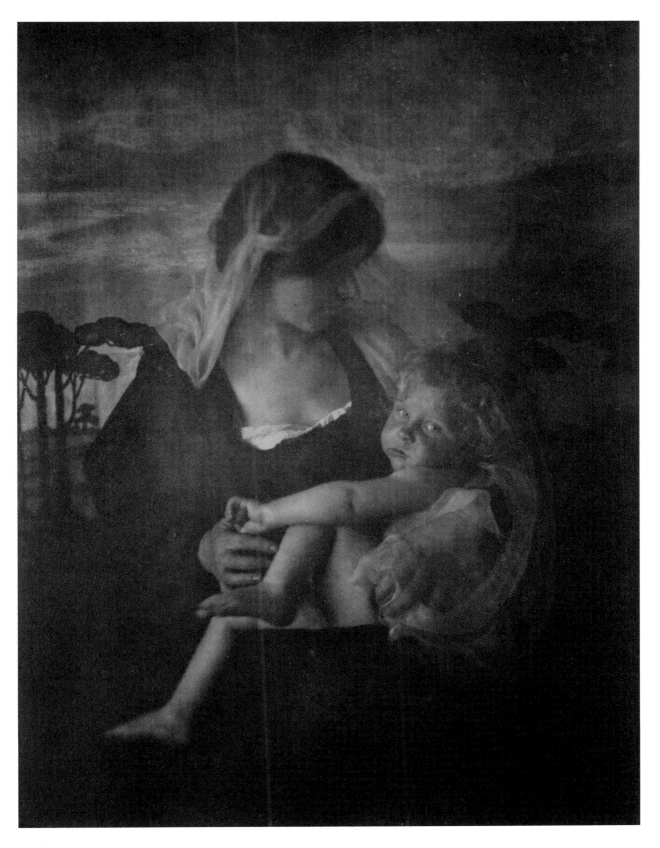

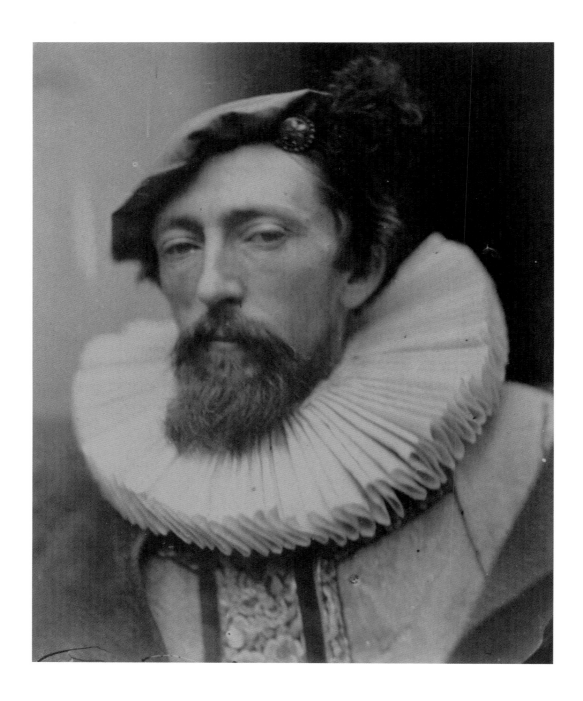

David Wilkie Wynfield (1837–1887)

John Evan Hodgson
1860s

Albumen print
18.9 x 15.4 cm

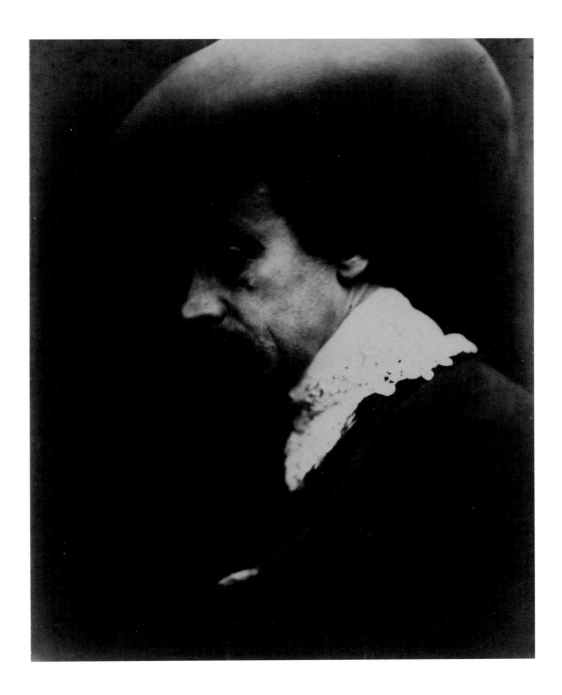

David Wilkie Wynfield (1837–1887)

Charles Samuel Keene
1860s

Albumen print
22.9 x 16.8 cm

The painter Wynfield was a founding member of the St John's Wood Clique in the early 1860s. The artists in the Clique shared an interest in historical genre subjects and often held fancy-dress gatherings. Wynfield's close-up photographs of his artist friends in medieval and Renaissance dress inspired Julia Margaret Cameron, who experimented extensively with costume and close framing.

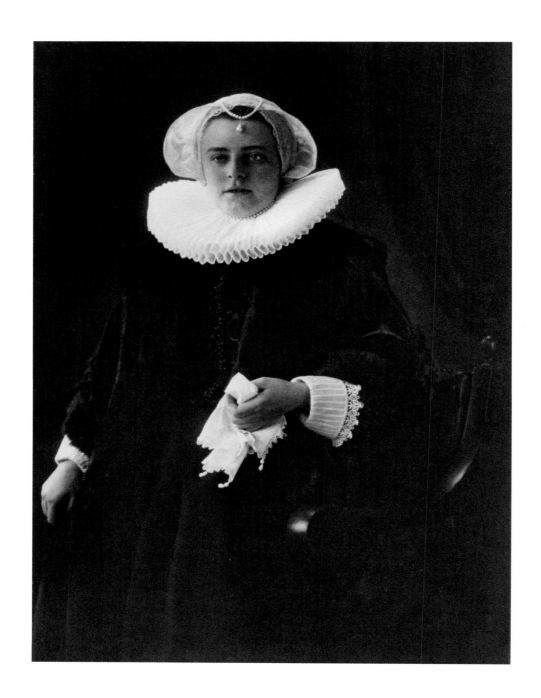

Richard Polak (1870–1957)

Portrait of a Lady Seated
1914

Platinum print
22.9 x 16.8 cm

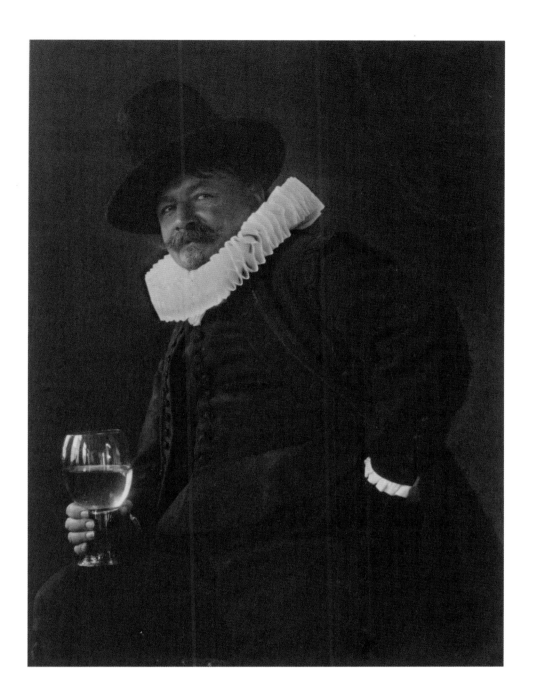

Richard Polak (1870–1957)

Man with a Glass
1915

Platinum print
22.9 x 16.8 cm

Polak furnished his Rotterdam studio with
antique props and theatrical costumes in order
to fulfil his ambition of creating photographic
versions of seventeenth-century Dutch paintings.
He produced a substantial body of work there,
including domestic scenes and portraits such
as these, which recall the paintings of Frans Hals.

Cindy Sherman (b.1954)

Untitled #199
1989

C-type print
63.5 x 44.3 cm

Sherman is one of the leading contemporary
practitioners of staged photography. Since the 1970s
she has photographed herself in myriad guises. By
demonstrating the mutability of her own appearance,
she draws attention to the constructed nature of
female identity in society. This photograph imitates
a portrait from the American Revolutionary period
and is from a series based on historical paintings.

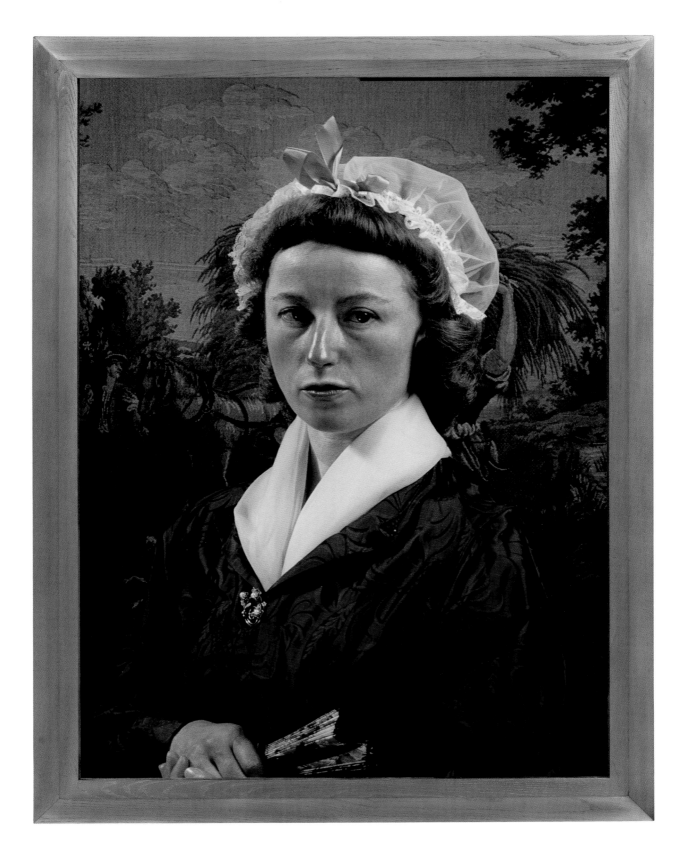

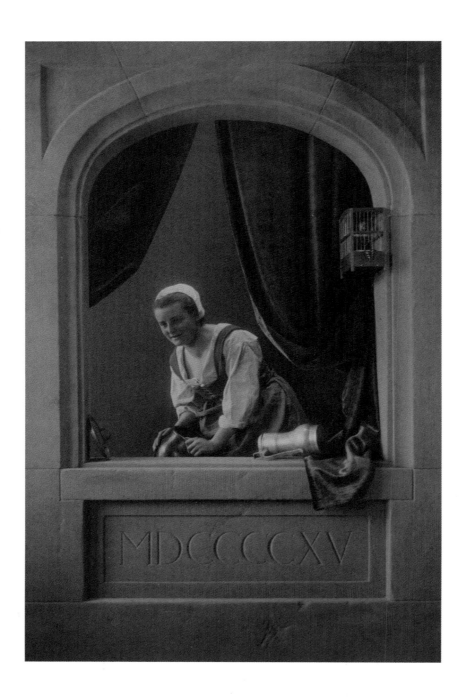

Richard Polak (1870–1957)

Cleaning Day
1915

Platinum print
21.9 x 13.7 cm

The source for this composition was a painting by Gerrit Dou of a woman washing pots and pans at a window. It even reproduces the conceit of the *trompe-l'œil* frame within a frame, which recurs in the seventeenth-century Dutch artist's work. While the original painting would have impressed viewers with its life-like precision, the photographic version is remarkable as a recreation of a painting.

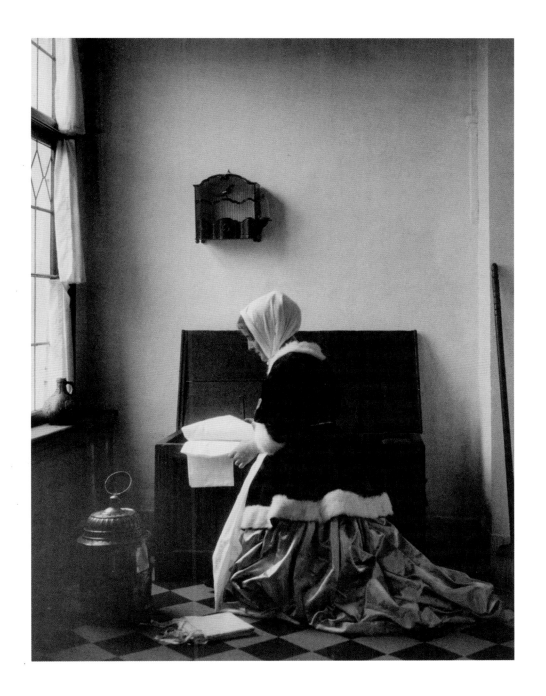

Richard Polak (1870–1957)

The Linen Chest
1913

Platinum print
22.8 x 17 cm

Tom Hunter (b.1965)

Woman Reading a Possession Order
1997

Dye destruction print and photocopy
60 x 40.8 cm and 29.7 x 21 cm

Hunter's depictions of contemporary people living in precarious urban conditions often make reference to historical paintings. He based this composition, from a series on London squatters, on *Girl Reading a Letter at an Open Window* (1657–9) by Johannes Vermeer. The copy of the actual eviction notice that accompanies the photograph sharply asserts the reality behind the carefully staged picture.

ORIGINAL SUMMONS

IN THE HIGH COURT OF JUSTICE

QUEEN'S BENCH DIVISION

IN THE MATTER OF LAND AND PREMISES KNOWN AS 8, LONDON LANE, LONDON E8
AND IN THE MATTER OF O.113 RSC

B E T W E E N :

THE MAYOR AND BURGESSES OF
THE LONDON BOROUGH OF HACKNEY **Plaintiffs**

and

PERSONS UNKNOWN **Defendants**

TO: EVERY PERSON IN OCCUPATION OF THE LAND AND PREMISES KNOWN AS 8
LONDON LANE, LONDON E8

LET all persons concerned attend before the Master in Chambers,

Room E103 at Royal Courts of Justice, Strand, London WC2 on Monday the 3rd of

February 1997 at 2°° o'clock on the hearing of an application by the Plaintiffs

THE MAYOR AND BURGESSES OF THE LONDON BOROUGH OF HACKNEY for an Order
that they do recover possession of the land and premises known as 8, London Lane ,
London E8 on the ground that they are entitled to possession and that the persons in
occupation are in occupation without licence or consent.

I certify that there are residential premises on the land mentioned herein.

Dated this 17 day of January 1997

This Summons was taken out by Christopher Hinde of 298 Mare Street London E8 Solicitor

for the Plaintiffs whose address is Town Hall Mare Street London E8 whose address for

service is 298 Mare Street London E8.

NOTE: Any person occupying the land who is not named as a Defendant by the
Summons may apply to the Court personally or by Counsel or Solicitor to be joined as a
Defendant. If a person occupying the land does not attend personally or by Counsel or by
Solicitor at the time and place above mentioned, such Order will be made as the Court
thinks just and expedient.

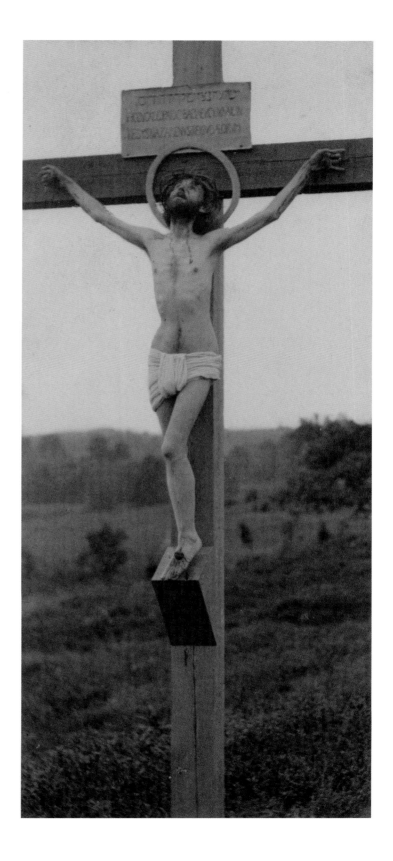

F. Holland Day (1864–1933)

The Crucifixion
1898

Platinum print
14.4 x 6.4 cm

Day was a strong proponent of art photography. His most daring series depicted the life of Christ. He cast himself in the central role, having grown his hair long and lost weight in preparation.

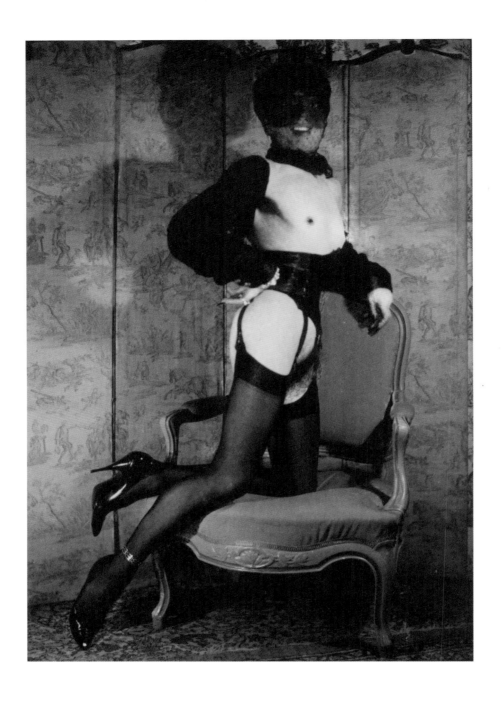

Pierre Molinier (1900–1976)

Autoportrait Genoux
1960

Gelatin silver print
12 x 9 cm

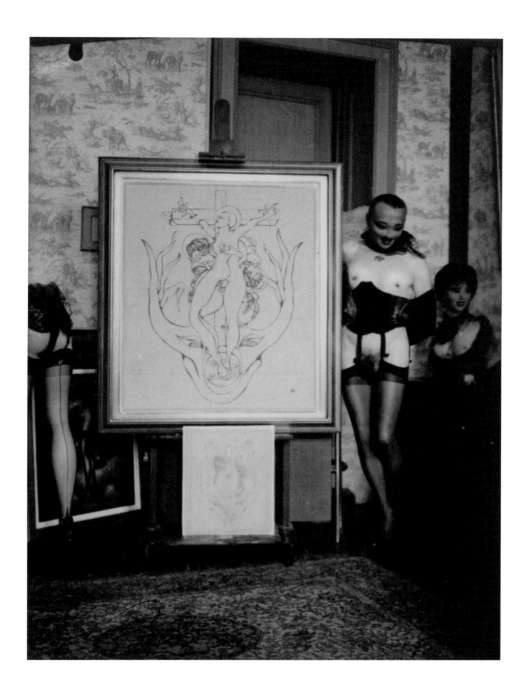

Pierre Molinier (1900–1976)

Autoportrait: Oh! ... Marie, Mère de Dieu
1965

Gelatin silver print
11.3 x 8.3 cm

Molinier explored his transsexual desires through a series of self-portraits, played out in his 'boudoir-atelier' in Bordeaux. In these small, darkly seductive photographs, Molinier appears transformed by his fetish wardrobe of fishnet stockings, suspender belt, stilettos, mask and corset. In making himself the staged subject of his work, Molinier anticipated the body art and performance art of the 1970s.

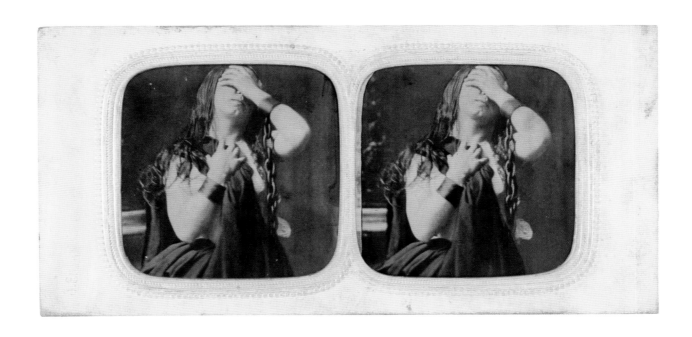

James Elliott (1835–1903)

The Captive
c.1860

Stereograph
8.5 x 17.5 cm

The specific story to which this image refers is unknown. Viewed in three dimensions through the intimacy of a stereoscope, the enchained, partially clad woman would have appeared all the more titillating. Hand-colouring — on a sheet of tissue behind the photograph and visible when the card was backlit — gave the figure a further life-like glow.

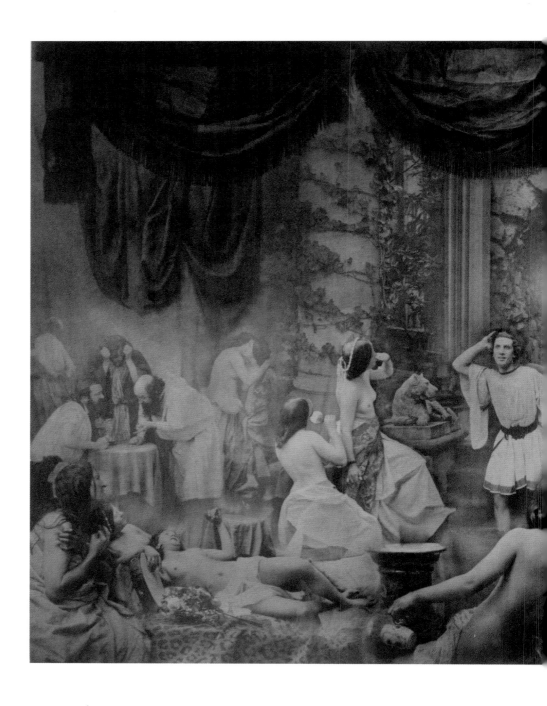

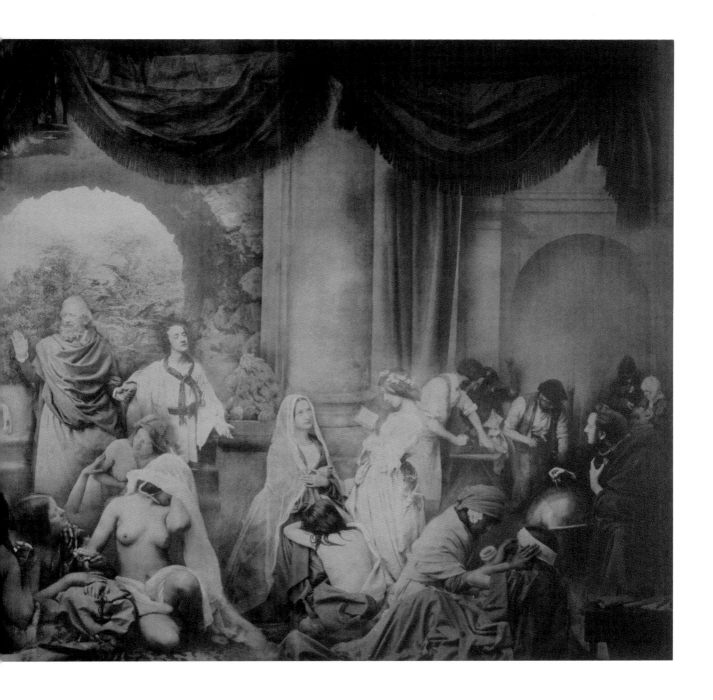

O.G. Rejlander (1813–1875)

Two Ways of Life
1857, printed 1925

Carbon print, after original albumen print
41.1 x 76.9 cm

(detail p.71)

Rejlander pioneered the technique of 'combination printing', whereby parts of a photograph are exposed independently but printed together to form a unified picture. He constructed this ambitious tableau from over thirty separate negatives in part to demonstrate that a photograph could be composed in the manner of a painting. The moralistic subject of two brothers choosing between vice and virtue also indicates the work's high art aspirations.

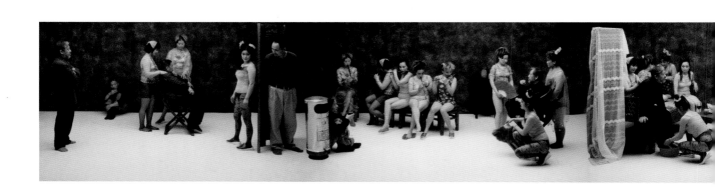

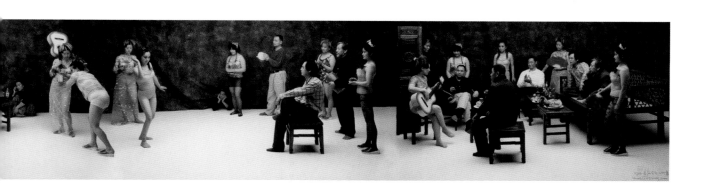

Wang Qingsong (b.1966)

Night Revels of Lao Li
2000

C-type print
30 x 240 cm

This photograph reworks *The Night Revels of Han Xizai*, a Chinese scroll painting from the tenth century. According to legend, the painting was made for the emperor by a court artist employed to spy on an official. Here the official is portrayed by Li Xianting, a Chinese art critic removed from his post in the 1980s for supporting experimental art. The photographer acts the part of the artist, observing each scene from the background.

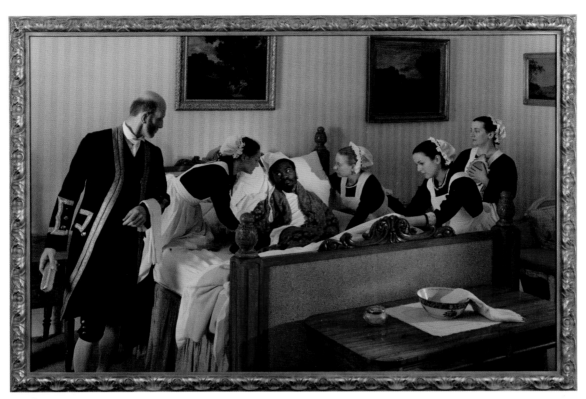

11.00 hours

Yinka Shonibare MBE (b.1962)

Diary of a Victorian Dandy
1998

C-type prints
122 x 183 cm each

In this series, Shonibare plays the role of a dandy, an outsider who uses his flamboyance, wit and style to penetrate the highest levels of society. Loosely based on William Hogarth's cycle of paintings and engravings *A Rake's Progress* (1733), the photographs follow the dandy's increasingly decadent activities throughout the day. As a playful comment on historic depictions of black people, Shonibare imagines himself as a central character in scenes set during the height of British colonial power.

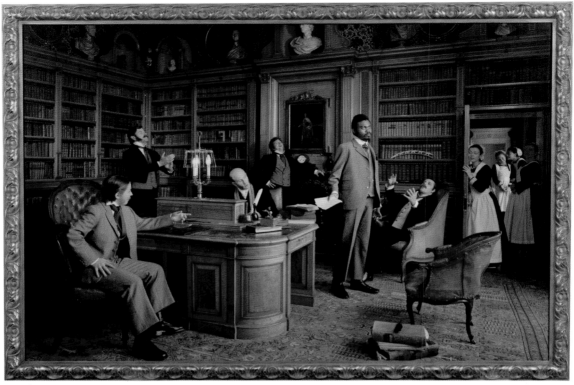

14.00 hours

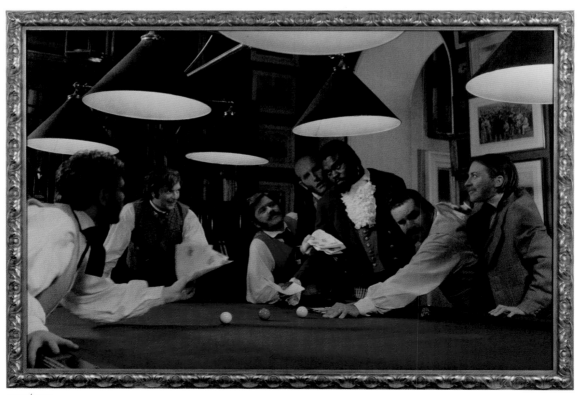

17.00 hours

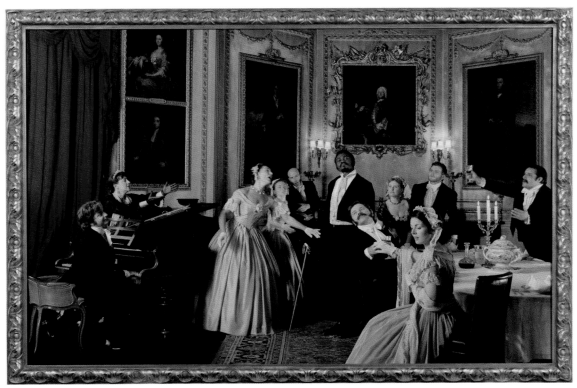

19.00 hours

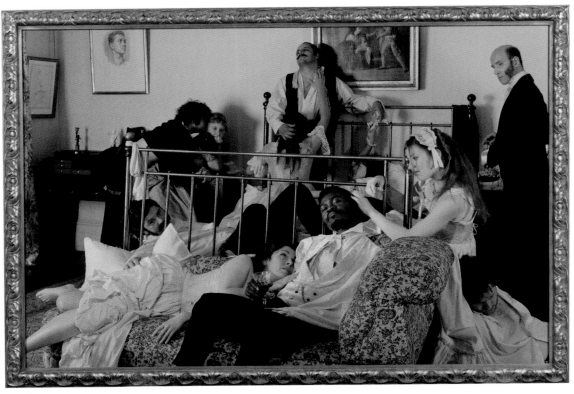

03.00 hours

1. Birth Scene
33 × 44.5 cm

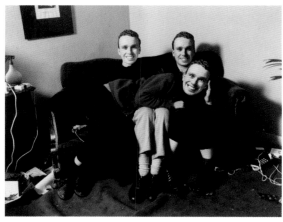

2. Childhood
33 × 42 cm

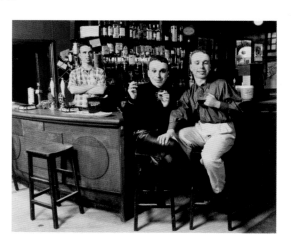

5. Meets his Match
33 × 39.5 cm

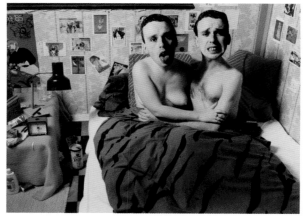

6. The Marriage
33 × 44.5 cm

Andy Wiener (b.1959)

from the series *A Rake's Progress*
1986

C-type prints

These photographs refer to William Hogarth's series of paintings about the downfall of an extravagant, womanizing 'rake'. All the figures wear masks of the same face (the photographer's own), suggesting the central character's egotism. While Hogarth's rake ends up in an insane asylum, Wiener's descends into madness in front of a television, in a scene the artist says 'corresponds to a modern Bedlam'.

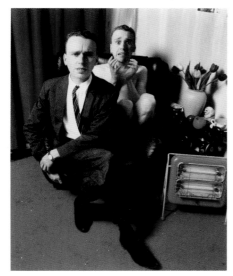

3. Coming of Age
43.4 × 34.2 cm

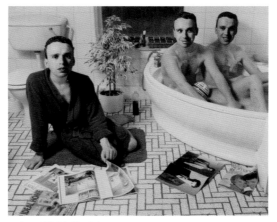

4. As an Eligible Bachelor
33 × 39.5 cm

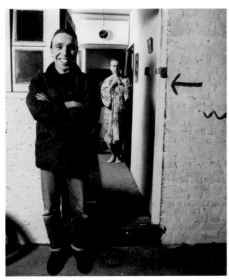

7. Shortly After the Marriage
41 × 32 cm

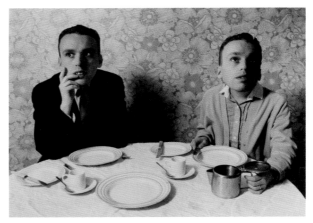

8. Breakfast Scene
33 × 45 cm

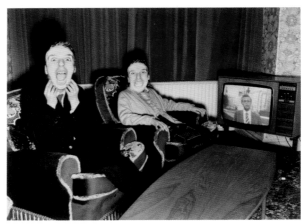

9. Sometime After the Marriage
33 × 44.5 cm

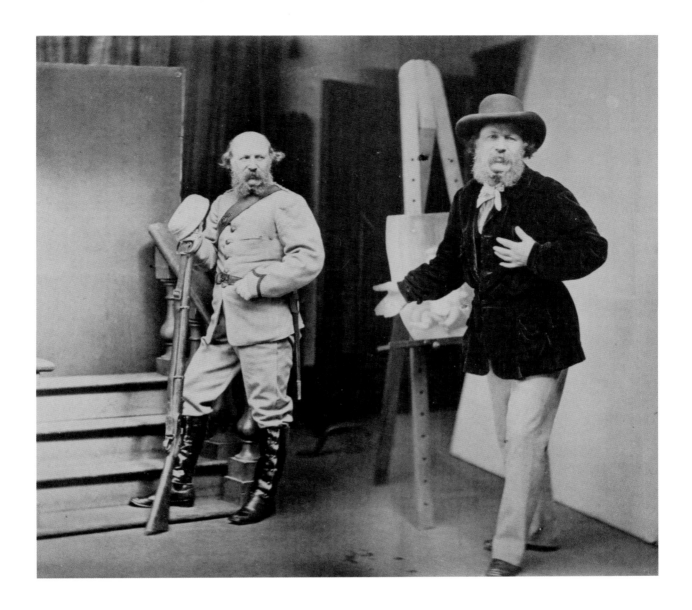

O.G. Rejlander (1813–1875)

O.G.R. the Artist Introduces O.G.R. the Volunteer
c.1871

Albumen print
9.9 x 11.1 cm

Rejlander enacted numerous roles in front of his own camera. Here, thanks to darkroom trickery, he plays two at once: that of the artist, and that of the volunteer soldier. The picture playfully demonstrates the multiple capabilities of photography as a seemingly authoritative documentary tool and as a means of conjuring the imaginary.

CHOLERIC. SANGUINE.

PHLEGMATIC. MELANCHOLY.

London Stereoscopic Company (*c.*1854–1922)

Cartes-de-visite of Ernst Schulz
*c.*1867

Albumen prints
5.7 x 4.2 cm each

Schulz was a German entertainer who impressed London audiences in 1867 with his show *Masks and Faces; or Studies of Character and Physiognomy*, in which he performed in rapid succession numerous emotions, characters, and racial and national stereotypes of the day. These small, collectible cards show the range of his repertoire. Charles Darwin, who included photographs in his book *The Expression of the Emotions in Man and Animals* (1872), owned a set of portraits of Schulz.

THE FAST MAN. THE PROFESSOR.

THE SOFT MAN. THE JOKER.

CANT. MEPHISTOPHELES.

MANIAC. SELF SATISFACTION.

HYPOCRISY. PRIDE.

JEAN QUI RIT. JEAN QUI PLEURE.

SUNDAY AFTERNOON. COQUETTE.

PIOUS OLD MAID. SHREW.

TURK. CHINESE.

NEGRO. INDIAN.

Maxine Walker (b.1962)

Untitled
1995

C-type prints
61 x 50.8 cm each

Walker draws attention to racial stereotypes as she photographs herself in a variety of guises. She presents her different skin tones and hairstyles as though they were instantaneous transformations made in a photo booth. The series invites consideration of the politics of such cosmetic choices.

Jo Spence (1934–1992)
in collaboration with Rosy Martin (b.1946)

Phototherapy: My Mother as a War Worker
1985

C-type print
92.2 x 60.5 cm

Jo Spence (1934–1992)
in collaboration with Rosy Martin (b.1946)

Phototherapy: My Mother, ca.1952
1985

C-type print
91.5 x 61 cm

In collaboration with psychoanalyst Rosy Martin, Spence developed a practice called 'phototherapy', which aimed to resolve emotional issues or past traumatic experiences through role-play and photographic portraiture. Here Spence addresses her difficult relationship with her mother. By dressing up and acting as her, she attempts to empathize more profoundly with her mother as an individual, with experiences and hardships of her own beyond the role of motherhood.

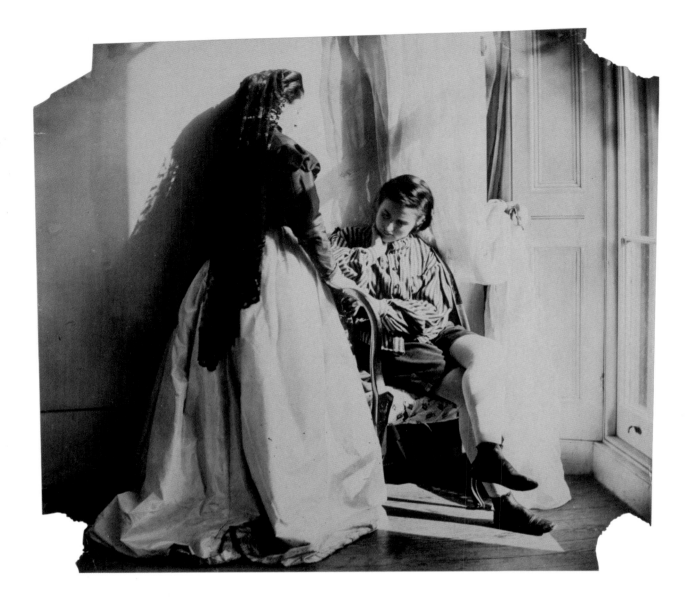

Clementina, Lady Hawarden (1822–1865)

Studies from Life, or *Photographic Studies*
c.1863–4

Albumen prints
114 24.4 x 26.6 cm
115 23.9 x 26.9 cm
116 23.8 x 27.3 cm
117 24.1 x 28.7 cm

Lady Hawarden made many staged tableaux using her two eldest daughters as models. Here they portray scenes of courtship. They enact the intimacy of lovers while also evoking the emotional closeness between mother and daughter, and between sisters. The photographs were torn from albums and, since they have no captions, the narrative is left to the viewer's imagination.

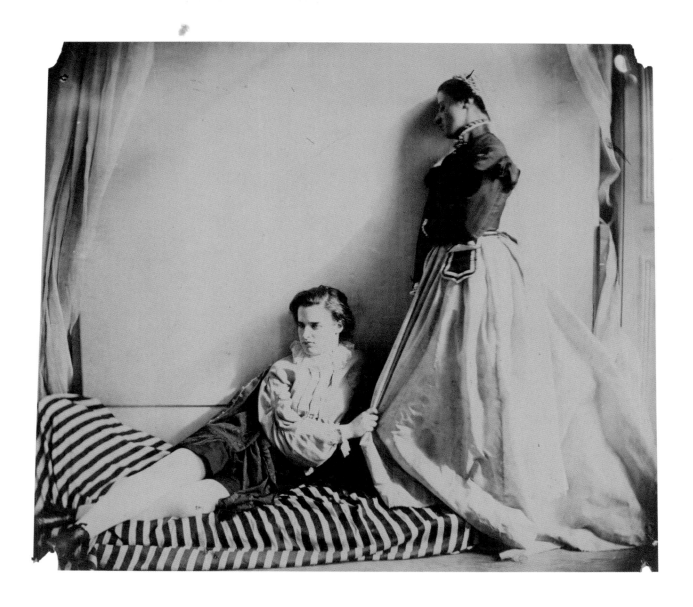

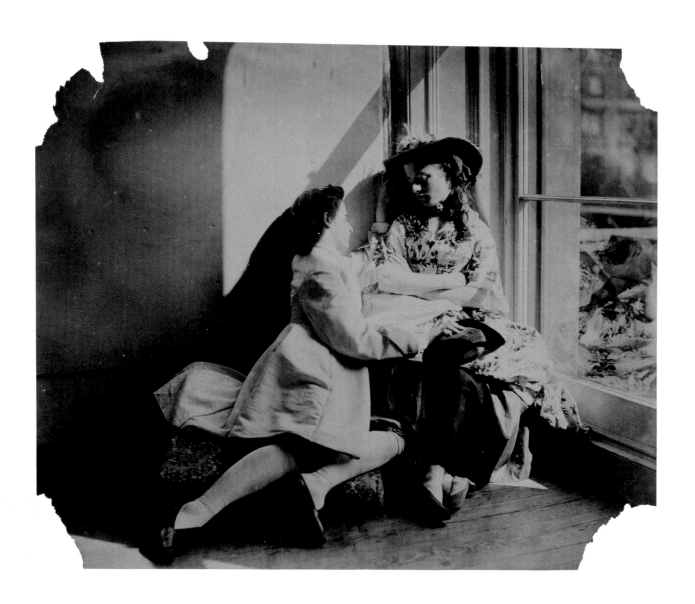

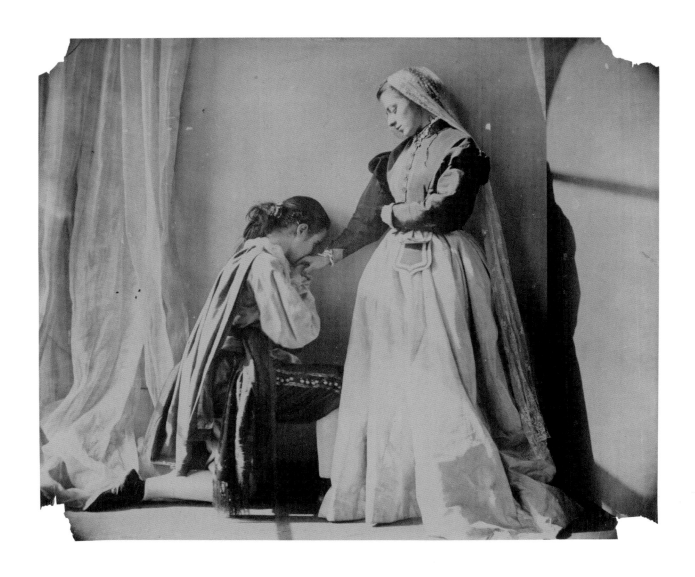

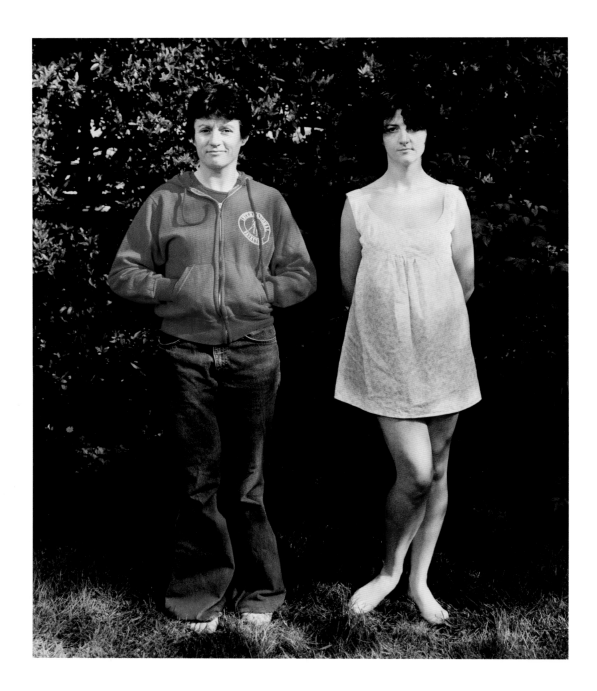

Trish Morrissey (b.1967)

Untitled, 2001
from the series *Seven Years*
2001

C-type print
61 x 50.8 cm

In her series *Seven Years*, Morrissey investigates
family photographs and the relationships that
lie behind them. The title refers to the age gap
between Morrissey and her elder sister, with
whom she collaborates. Together, they stage
images of themselves impersonating relatives,
both real and imagined. The photographs
imitate family snapshots, which are also often
self-consciously posed.

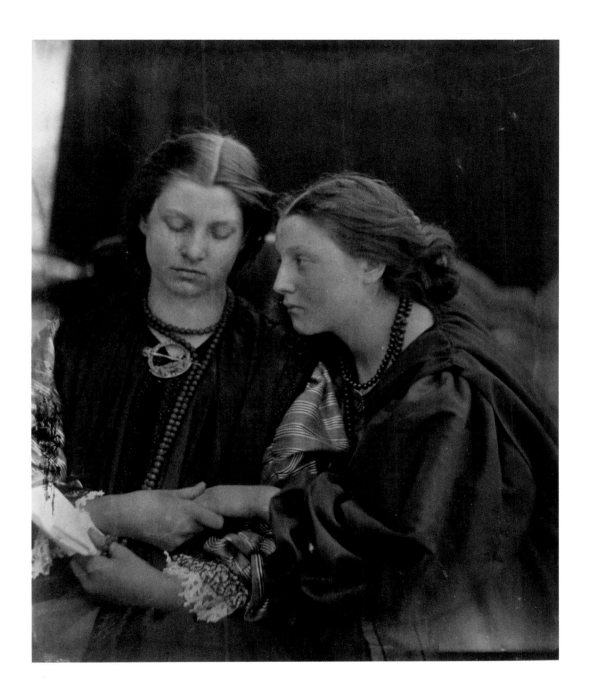

Julia Margaret Cameron (1815–1879)

Yes or No?
1865

Albumen print
25 x 21 cm

(detail p.113)

The subject of this picture seems to be a marriage proposal. As in many of Cameron's compositions, there is a sense of physical and emotional closeness between the sitters. Their hands intertwine over a mass of overlapping drapery, and the figures lean together in a triangular formation that recurs in Cameron's group photographs. She may have found inspiration in the sentimental genre painting popular with her Victorian contemporaries.

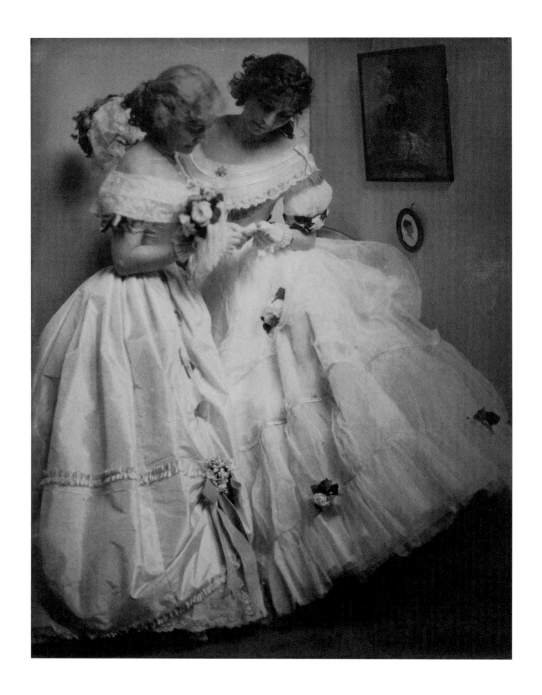

Gertrude Käsebier (1852–1934)

The Letter
1906

Platinum print
20.8 x 15.5 cm

Käsebier studied painting before opening a photography studio in New York. Her Pictorialist photographs often combine soft focus with experimental printing techniques. These sisters were dressed in historic costume for a ball, but their pose transforms a society portrait into a narrative picture. In a variant image, they turn o look at the framed silhouette on the wall.

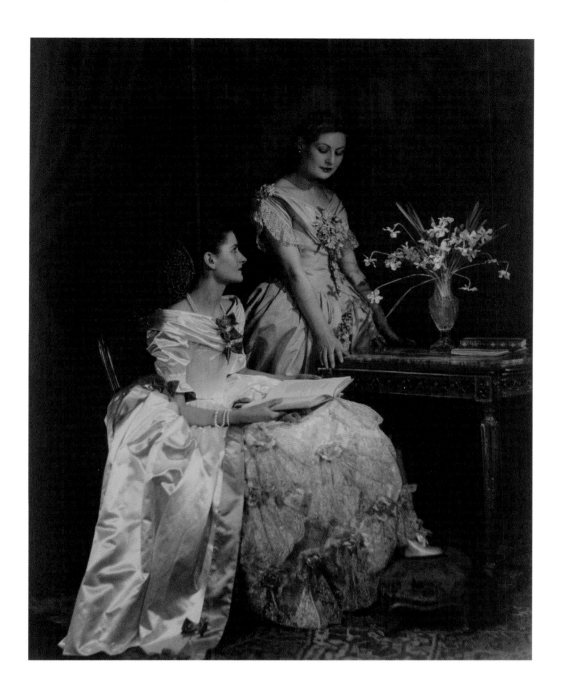

Rosalind Maingot (1894–1947)

The Poem
1943

Gelatin silver print
47.9 × 37.3 cm

After a career as an actress in Australia,
Maingot married a British surgeon and became
a photographer in London. Her output was
varied, encompassing medical photography
as well as costumed tableaux such as this one.

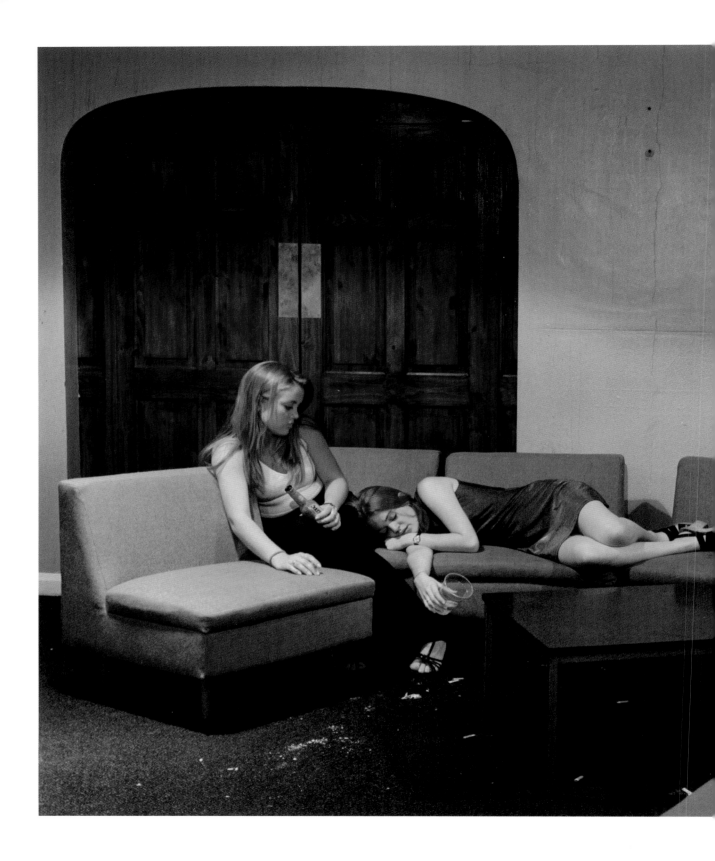

Hannah Starkey (b.1971)

Untitled, May 1997
1997

C-type print
122 x 160.5 cm

Starkey uses female actors to create carefully
staged, large-scale tableaux. Her photographs
depict plausible, even familiar, incidents from
everyday life, but the absorption of the characters
and the epic scale of the prints suggest greater
significance. As in Lady Hawarden's photographs,
this work shows a moment of intimacy between
two adolescent girls.

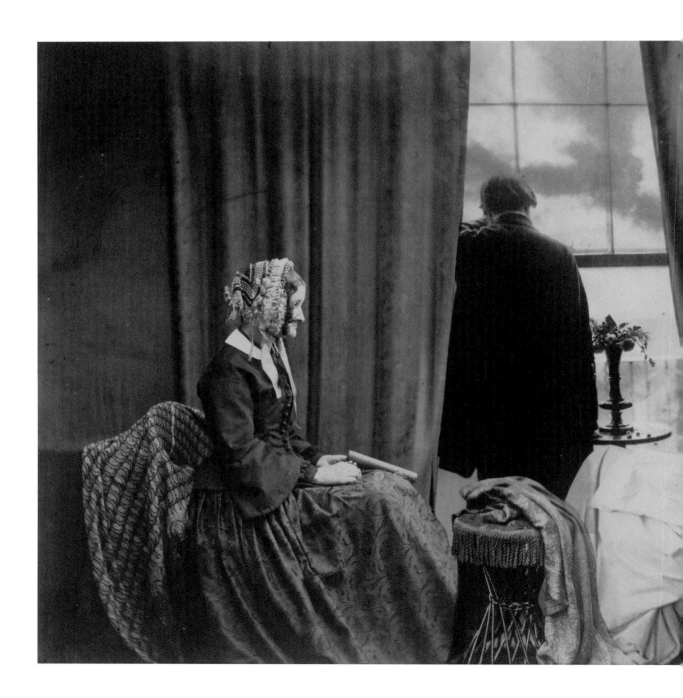

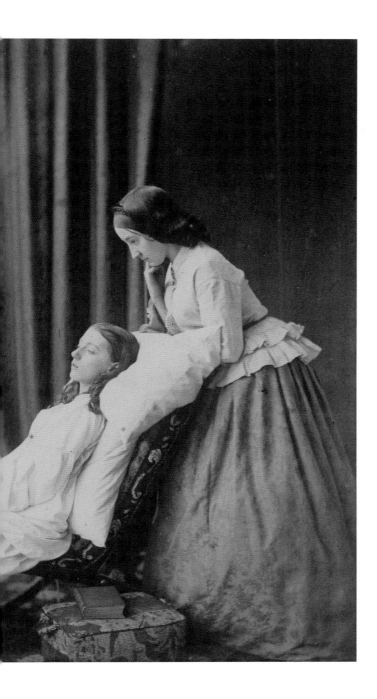

Henry Peach Robinson (1830–1901)

Fading Away
1858

Albumen print
23.8 x 37.5 cm

(detail p.6)

This was one of the most famous and controversial tableau photographs of the Victorian period. Depicting the final moments of a graceful young consumptive surrounded by her family, it was composed from five separate negatives, using a technique that Robinson had learned from O.G. Rejlander. Critics were less concerned with the picture's overt theatricality than with whether forming a single picture from negatives taken on different occasions constituted a betrayal of photography's truthfulness.

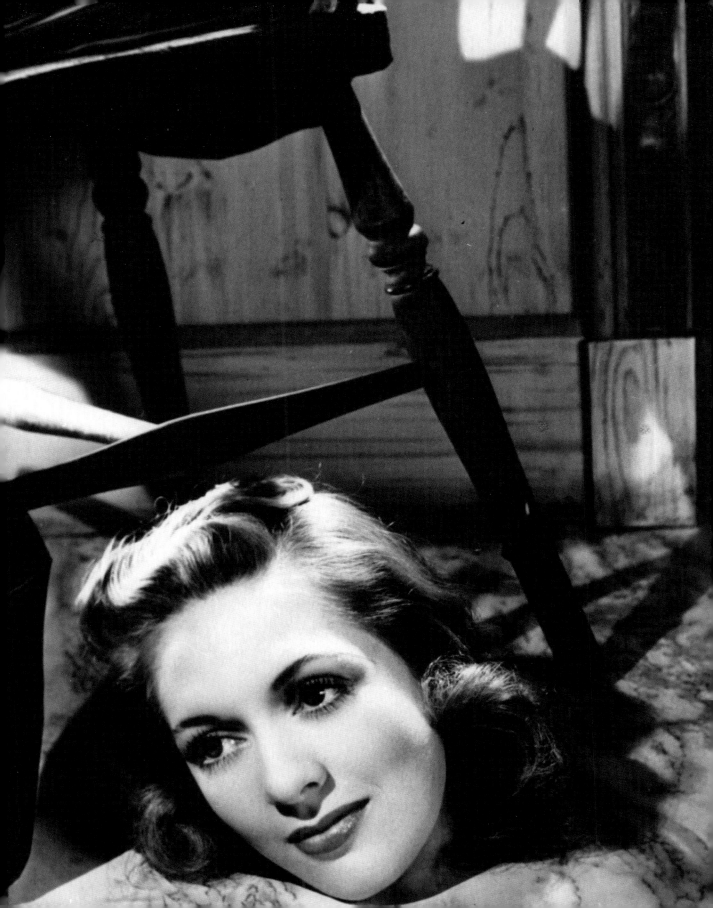

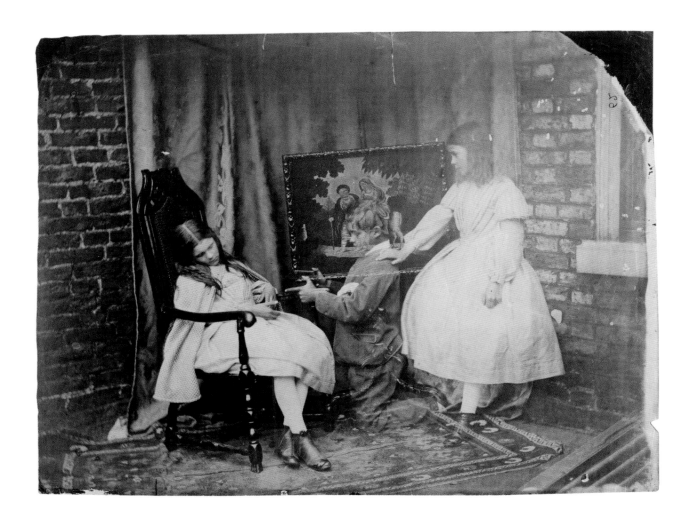

Charles Lutwidge Dodgson
(aka Lewis Carroll) (1832–1898)

The Dream
1863

Albumen print
19.2 x 25.1 cm

Dodgson photographed children feigning sleep on numerous occasions. Here he also experimented with double exposure to evoke the contents of the slumbering girl's dream. The photograph dates from the same time that he wrote *Alice's Adventures in Wonderland*, most of which takes place in a dream world.

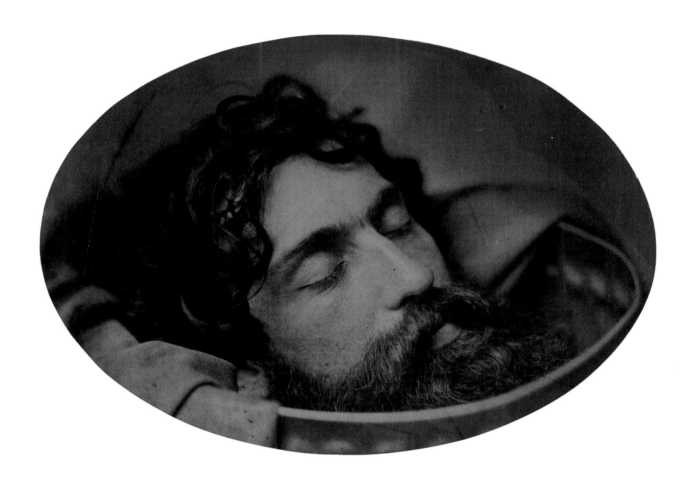

O.G. Rejlander (1813–1875)

Head of St John the Baptist on a Charger
*c.*1856

Albumen print
10.5 x 15 cm

Rejlander probably intended this photograph as part of a larger composition depicting the biblical episode in which John the Baptist's head was presented to Salome on a platter, or 'charger'. Rejlander never made the full picture, however, and instead produced multiple prints of the head alone.

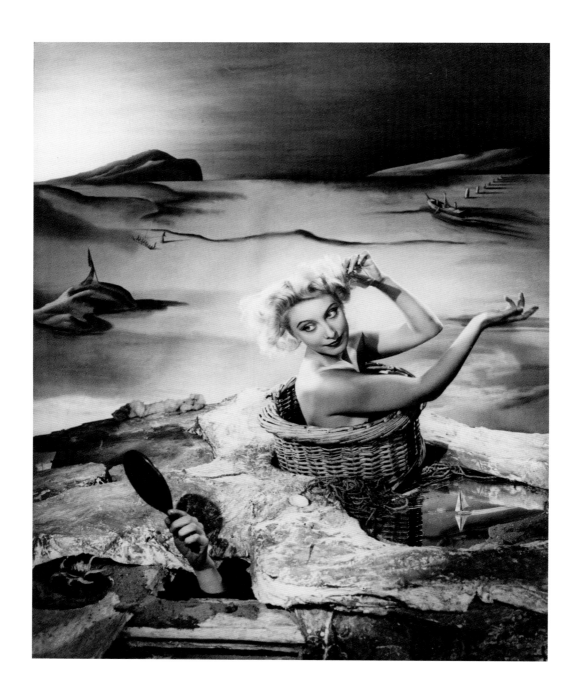

Angus McBean (1904–1990)

A Day Dream
1938

Gelatin silver print
49.2 x 38 cm

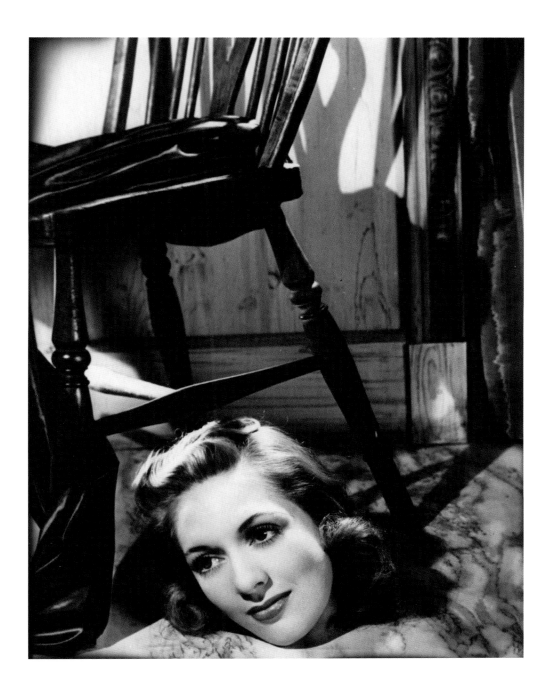

Angus McBean (1904–1990)

Surreal portrait of Diana Churchill
1940

Gelatin silver print
49.2 x 38 cm

(detail p.127)

McBean staged surrealistic scenes in his studio rather than creating them with darkroom manipulation. To make this portrait of actress Diana Churchill, he built an elaborate set with a hole through which the actress could insert her head. He photographed several models in this manner.

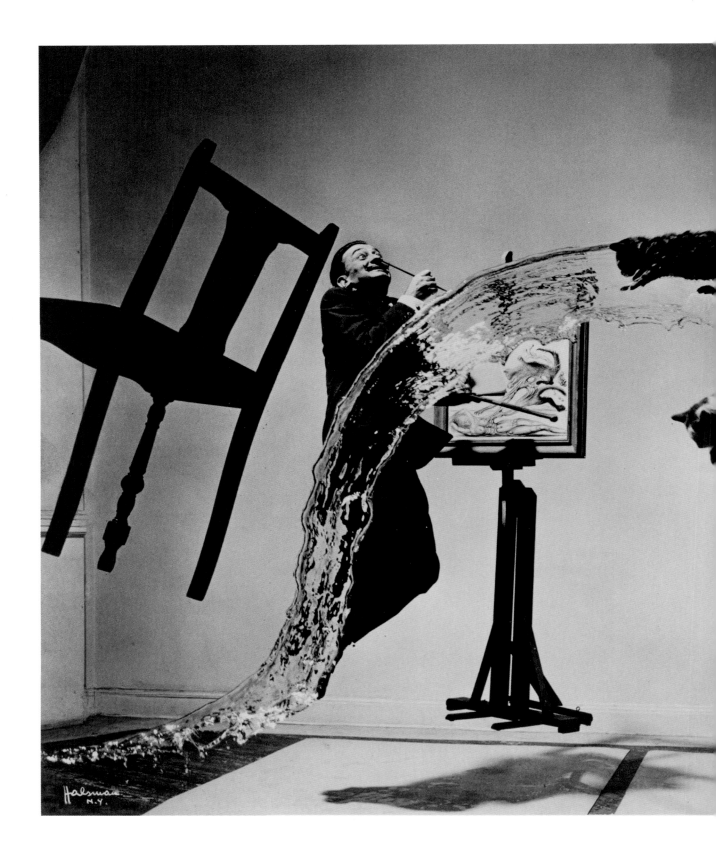

Philippe Halsman (1906–1979)

Dalí Atomicus
1948

Gelatin silver print
26.9 x 34 cm

Halsman was a portrait photographer known for capturing his subjects jumping in mid-air. He also collaborated extensively with the Surrealist artist Salvador Dalí. This image was inspired by Dalí's painting *Leda Atomicus*, in which figures and objects are suspended in the air. The painting appears at the far right. It took Halsman — and a team of assistants throwing cats and water — numerous attempts to achieve the final result.

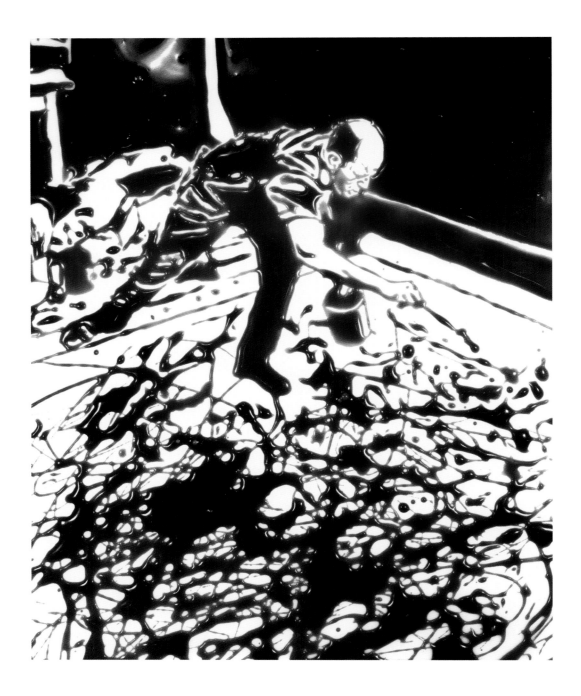

Vik Muniz (b.1961)

Action Photo (After Hans Namuth)
from the series *Pictures of Chocolate*
1997

Dye destruction print
152.4 x 121 cm

Muniz recreates well-known images with materials such as chocolate, sugar and thread. He then makes a photographic record of these 'drawings'. Here, he reproduces a famous photograph of the painter Jackson Pollock at work. The sticky chocolate sauce echoes the characteristic drips of paint in Pollock's work.

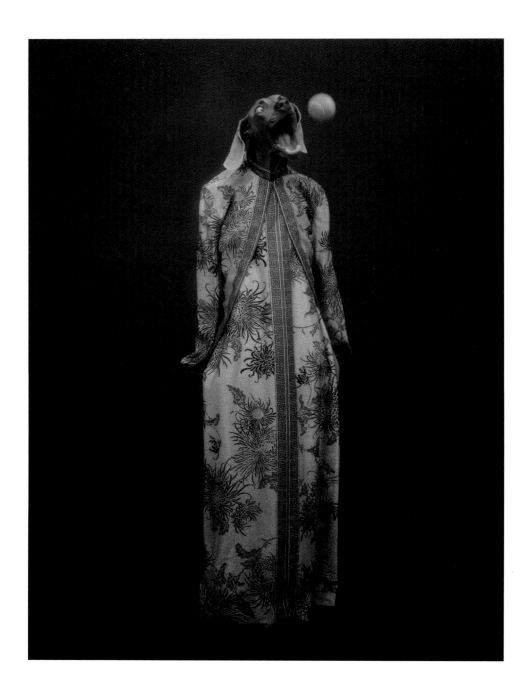

William Wegman (b.1943)

Dressed for Ball
1988

Polacolor II print
61 x 50.8 cm

Humour and wordplay are recurring motifs in Wegman's staged portraits of his Weimaraner dogs. This was his first foray into dressing the dogs in human clothes, although the artist has explained that the dog, Fay Ray, was not actually wearing the dress. Instead, Wegman suspended it on a hanger around the dog's neck and draped it over the table on which she was seated.

W.G. Campbell (1810–1881)

The Lesson
1856

Albumen print
15 x 17.7 cm

This was Campbell's contribution to the 'Photographic Album for the Year 1857', a collection of photographs by members of a club within the Photographic Society. Both sitters had to hold their poses for a seven-second exposure. An accompanying poem explains that the subject is not merely amusing but moralistic. The 'lesson' is, in fact, one humans might learn from canine obedience and deferred gratification.

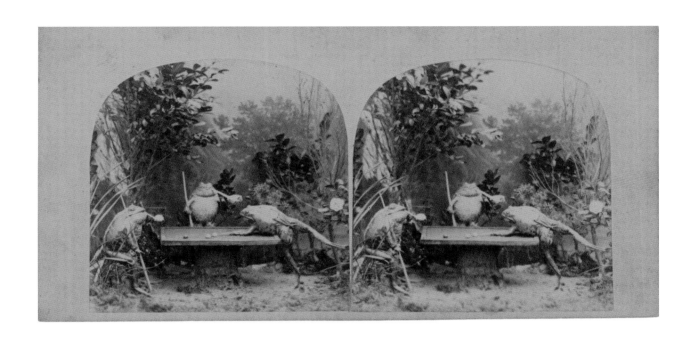

Charles Furne (1824–1880)
and Henri Tournier (1835–1885)

Frogs Playing Pool and Smoking Clay Pipes
c.1860

Stereograph
8.6 x 17.2 cm

Stereographs were produced in vast quantities and depicted a great range of subjects, from the educational to the absurd. At the humorous end of the spectrum were novelties such as stuffed frogs playing pool, cartoonish domestic scenes and supernatural tableaux.

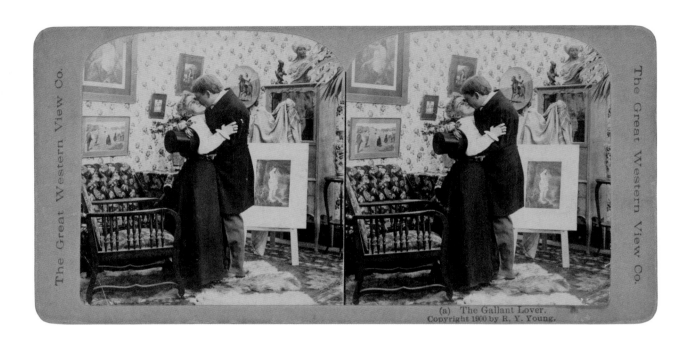

R.Y. Young (fl.1899–1903)

The Gallant Lover
1900

Stereograph
8.9 x 17.9 cm

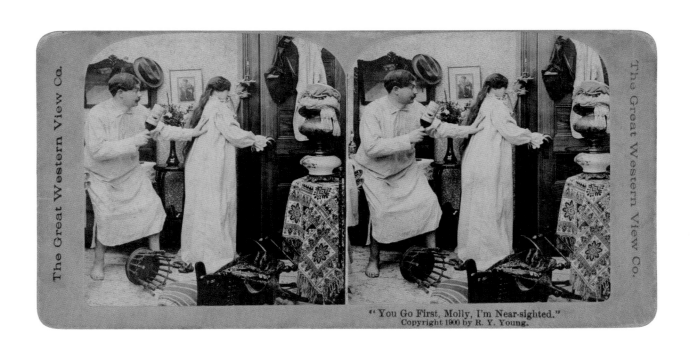

"You Go First, Molly, I'm Near-sighted."
Copyright 1900 by R. Y. Young.

R.Y. Young (fl.1899–1903)

You Go First Molly, I'm Near-sighted
1900

Stereograph
8.9 x 17.9 cm

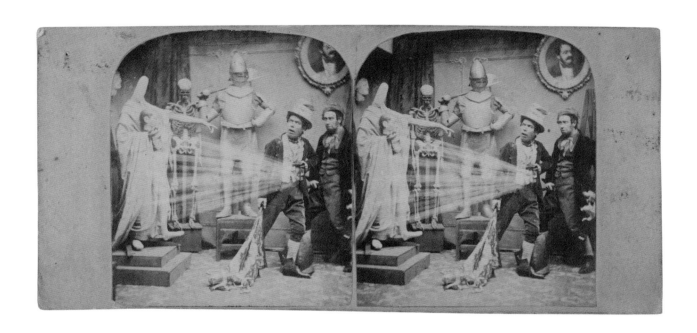

Martin Laroche (1814–1886)

Astounding Apparition!
*c.*1860

Stereograph
8.2 x 17.5 cm

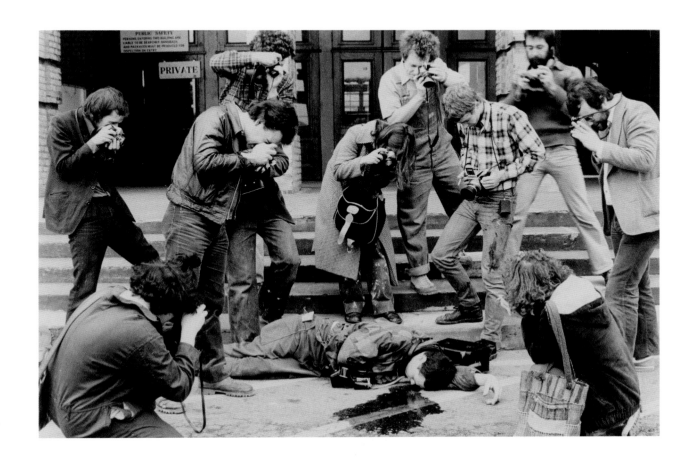

John A. Walker (b.1938)
and Carolyn Davies (dates unknown)

Atrocity! Death of a Photographer
1979

Gelatin silver print
19.5 x 28.8 cm

This satirical photograph was staged by art students
and faculty members at Middlesex Polytechnic.
They intended it as a critique of the sensationalist
coverage of violence by photojournalists. Walker
later recalled: 'After the "shoot", the "corpse" rose
from the dead and resumed his studies.'

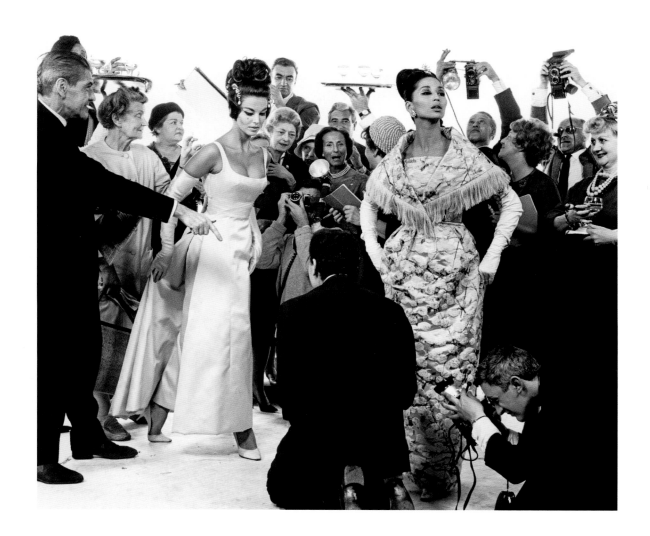

Richard Avedon (1923–2004)

*Margot McKendry and China Machado with
members of the French press, dresses by Lanvin-
Castillo and Heim, Paris, August 24, 1961*
1961

Gelatin silver print
35.3 × 49.5 cm

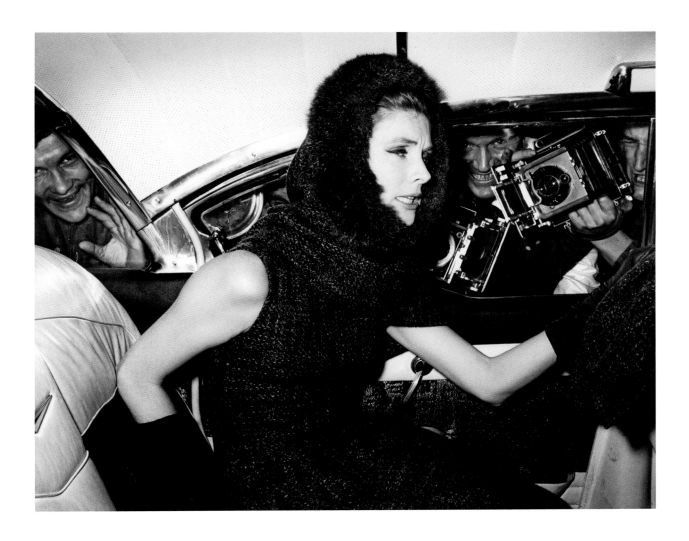

Richard Avedon (1923–2004)

*Suzy Parker, dress by Nina Ricci,
Champs-Élysées, Paris, July 29, 1962*
1962

Gelatin silver print
35.3 x 49.4 cm

In these staged scenes, Avedon mocks the very
industry in which he played such a major role —
fashion. In one picture, buyers, writers and
photographers clamour around two statuesque
figures. In the other, a model is caught inside
a car by a frenzied crowd of paparazzi.

Cindy Sherman (b.1954)

Untitled #74
1980

C-type print
39.9 x 59.2 cm

Sherman photographs herself in a
multitude of identities using carefully
constructed scenery, accessories and
attributes. Her work critiques stereotypical
imagery and deconstructs feminine roles.
This photograph is part of a series in which
Sherman enacts a range of female types
from the cinema of the 1950s and '60s.

Roger Fenton (1819–1869)

Nubian Water Carrier
1858

Albumen print
26.2 x 20.6 cm

This is one of several Orientalist fantasies that Fenton staged in his London studio. It may have been the result of a collaboration with the painter Frank Dillon, who had brought back props and costumes from his travels in Egypt. Although not visible here, in other photographs from the same series wires were clearly used to hold up the model's arms.

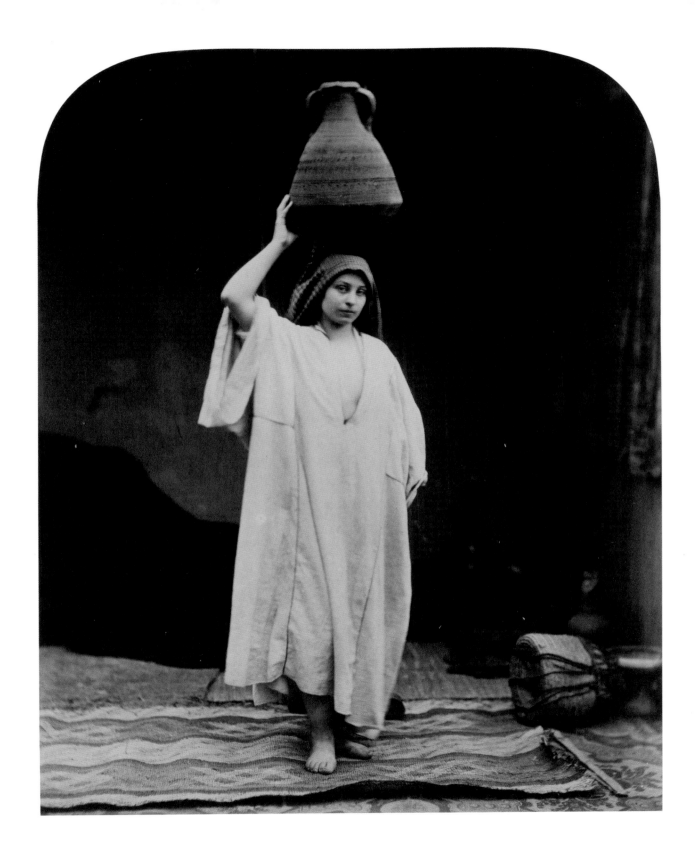

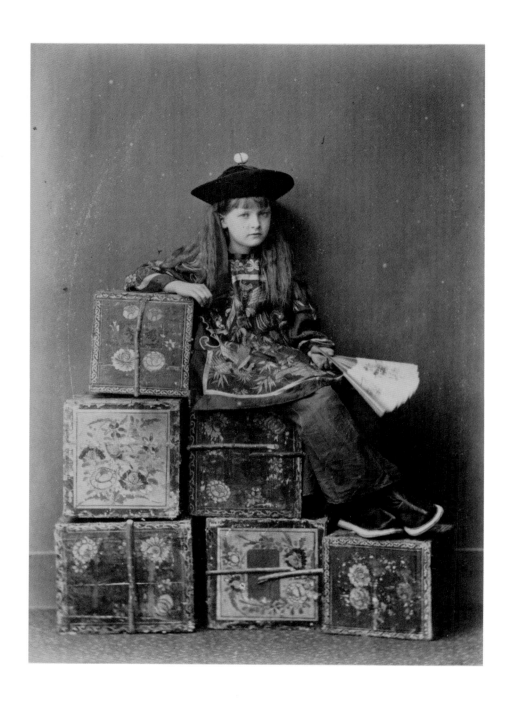

Charles Lutwidge Dodgson
(aka Lewis Carroll) (1832–1898)

Tea Merchant (On Duty)
1873

Albumen print
15 x 10.4 cm

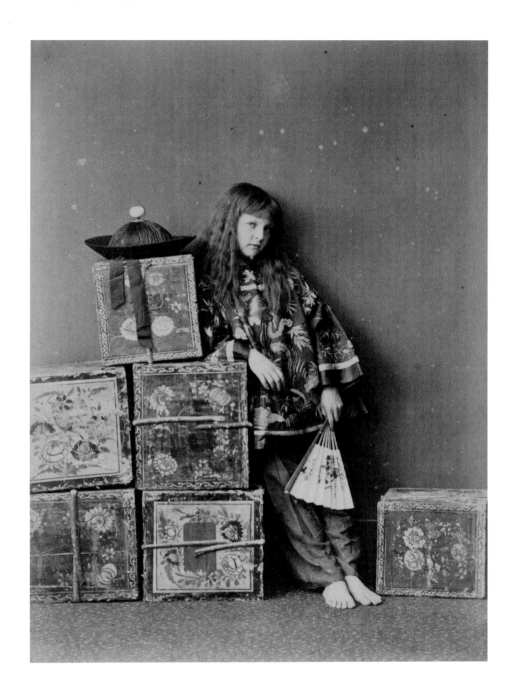

Charles Lutwidge Dodgson
(aka Lewis Carroll) (1832–1898)

Tea Merchant (Off Duty)
1873

Albumen print
15 x 10.4 cm

Dodgson made more photographs of Alexandra
'Xie' Kitchin than of any of his other child friends.
She posed on multiple occasions both as herself and
play-acting various roles. Dodgson photographed
her in other exotic-seeming costumes, including
Greek and Danish, but by adding props and pairing
the two variants of Xie in Chinese costume he
introduced a sense of narrative.

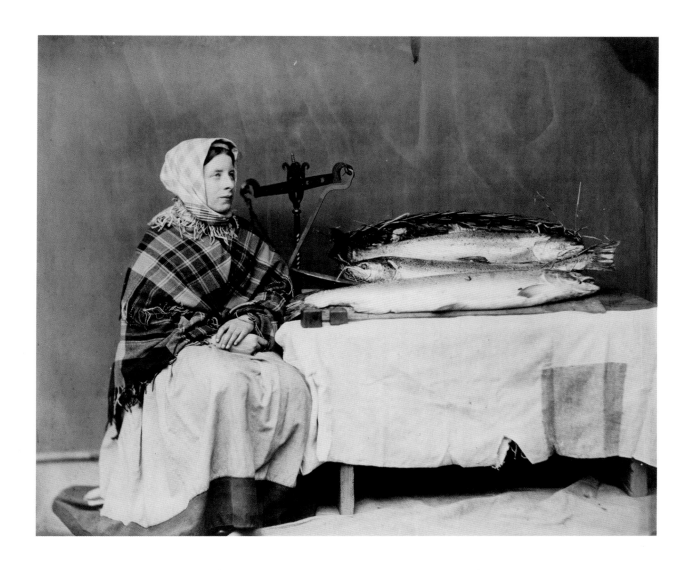

Robert Thompson Crawshay (1817–1879)

A Slow Market
1868

Albumen print
24.5 x 29 cm

Crawshay was the owner of an ironworks and an amateur photographer. The sitter is not actually a fishwife, but his daughter, Rose Harriette, whom he photographed in various guises. She wrote in her diary: 'Papa came in with the ugliest, dirtiest, nastiest old straw bonnet that ever existed and a cap (thank goodness that was clean) for me to be photographed in as a fish woman which lasted till lunch time.'

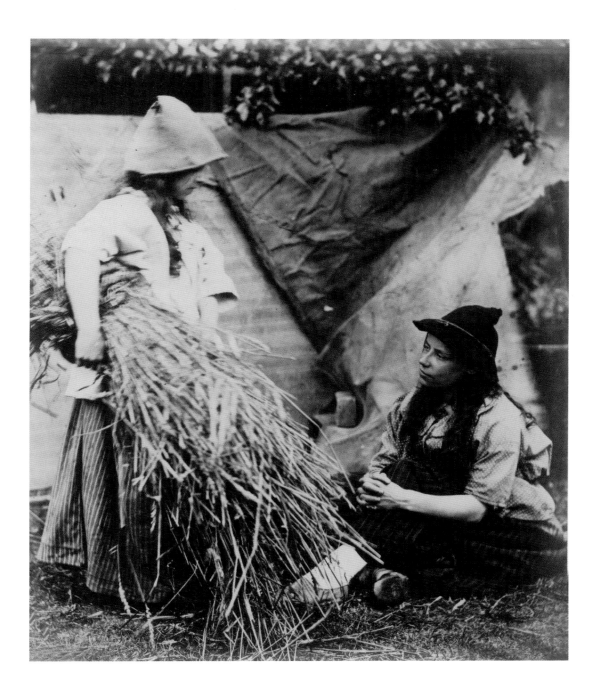

Sidney Richard Percy (1821–1886)

Untitled
*c.*1855

Albumen print
16.1 x 13.4 cm

Percy was a painter of rustic genre scenes who achieved success in the 1840s and '50s. He was also an amateur photographer. He made photographs as studies for paintings rather than as artworks. His models were servants and family members, not actual rural subjects. The cloth draped over the brick wall in the background hints at the staged nature of the composition.

Unknown photographer

Untitled
*c.*1880s

Albumen print
26 x 21 cm

The protagonist in this tableau is a lay figure, a mannequin used by artists in place of a live model. This one has been posed as an artist, holding a palette and brushes, and surrounded by a dense display of photographs, paintings and *objets d'art*. The photograph may have been made in the studio of the Italian landscape painter Giovanni Costa (1826–1903).

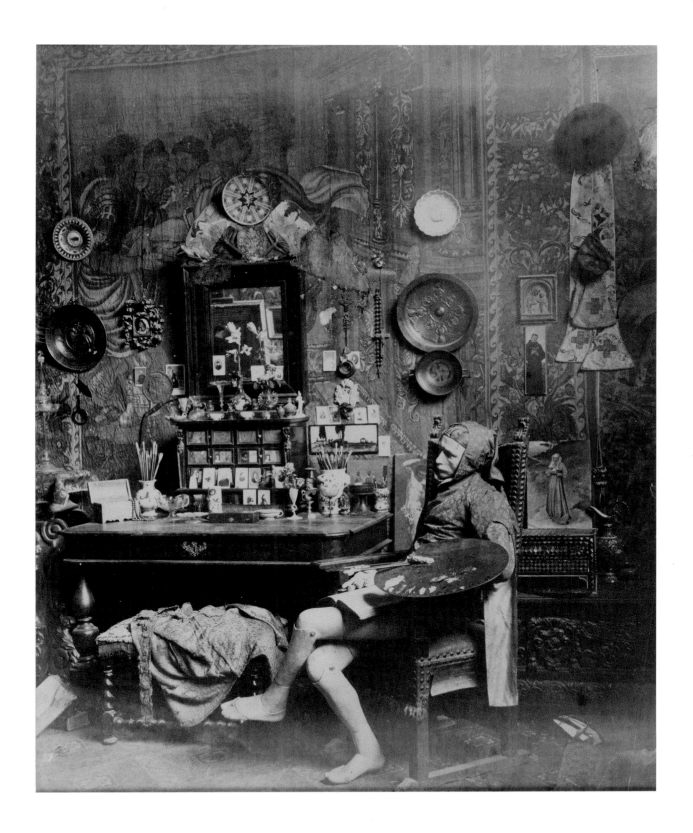

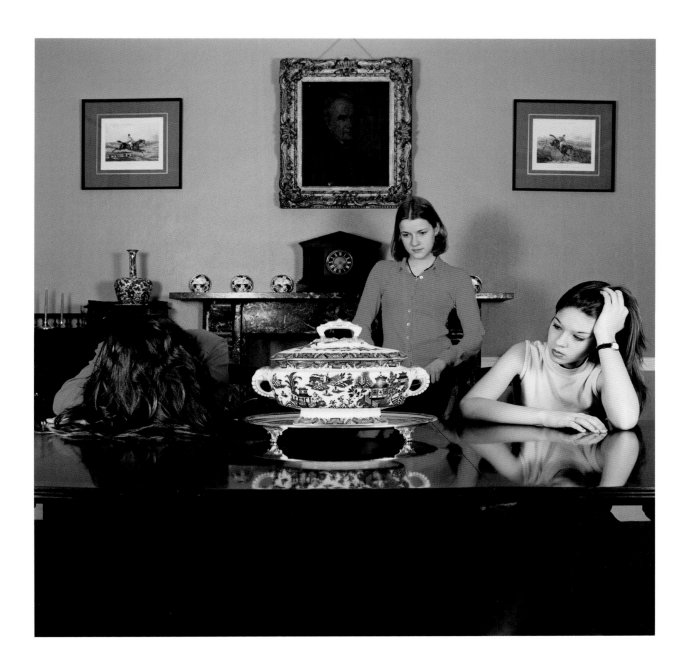

Sarah Jones (b.1959)

The Dining Room (Francis Place) (II)
1997

C-type print
150 x 150 cm

(detail p.153)

Jones constructs scenes that are inspired both
by psychoanalysis and the history of art. Here
three adolescent girls seem poised in reverie in the
polished setting of a well-appointed dining room.
The emotions implied by their attitudes and the
possible symbolic significance of objects in the
room, such as the central ceramic dish, are left
open to interpretation. The result is mesmeric,
yet ultimately enigmatic.

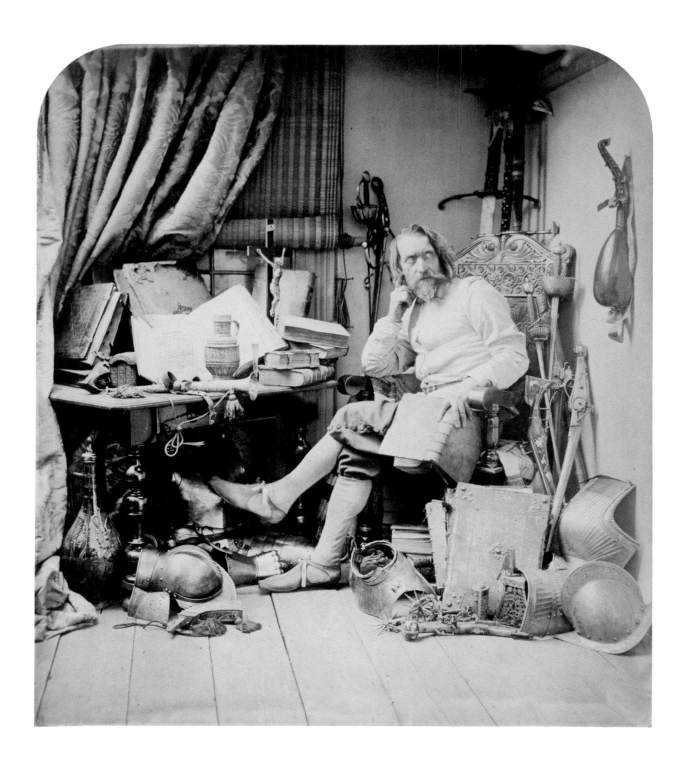

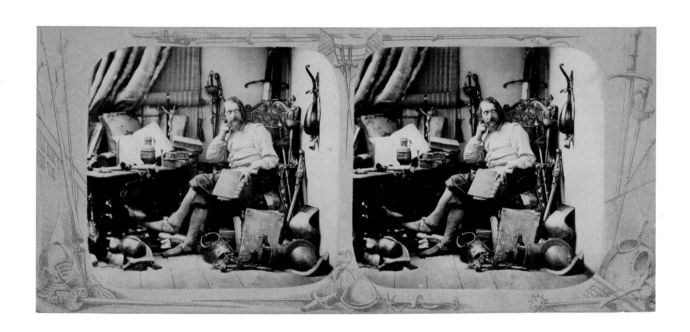

William Frederick Lake Price (1810–1896)

Don Quixote in his Study
1855

Albumen print
32.4 x 28.3 cm

Stereograph
8.4 x 17.5 cm

Literary scenes were typical subjects for Victorian painters but more controversial for photographers. The Victoria and Albert Museum's founding director, Sir Henry Cole, disliked historical costume-piece photographs, saying, 'the dramatic Scenes I think failures', but he did purchase a still life by Lake Price for the Museum. Lake Price's work inspired Charles Dodgson (aka Lewis Carroll) to make similar tableau-like photographs. Unlike the large exhibition print, which aimed to be high art, the stereograph version was intended for mass distribution. The cluttered interior would have been particularly impressive seen in three dimensions.

Jan Wenzel (b.1972)

Bastler IX (Tinkerer IX)
2000

C-type prints
21.5 x 16.5 cm

This tableau is made up of four photo-booth strips. Wenzel works almost solely with photo booths, a format in which the camera dictates the framing and timing of each exposure. He set up this scene inside a photo booth in his studio and rearranged each frame at 28-second intervals. The figure of the 'tinkerer', surrounded with wires and mechanical fragments, reflects Wenzel's inventive and experimental technique.

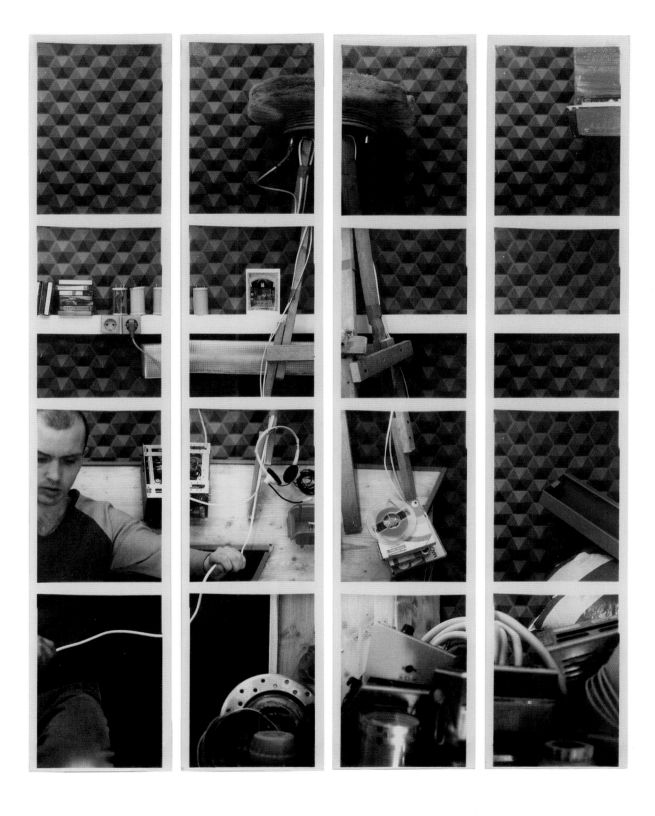

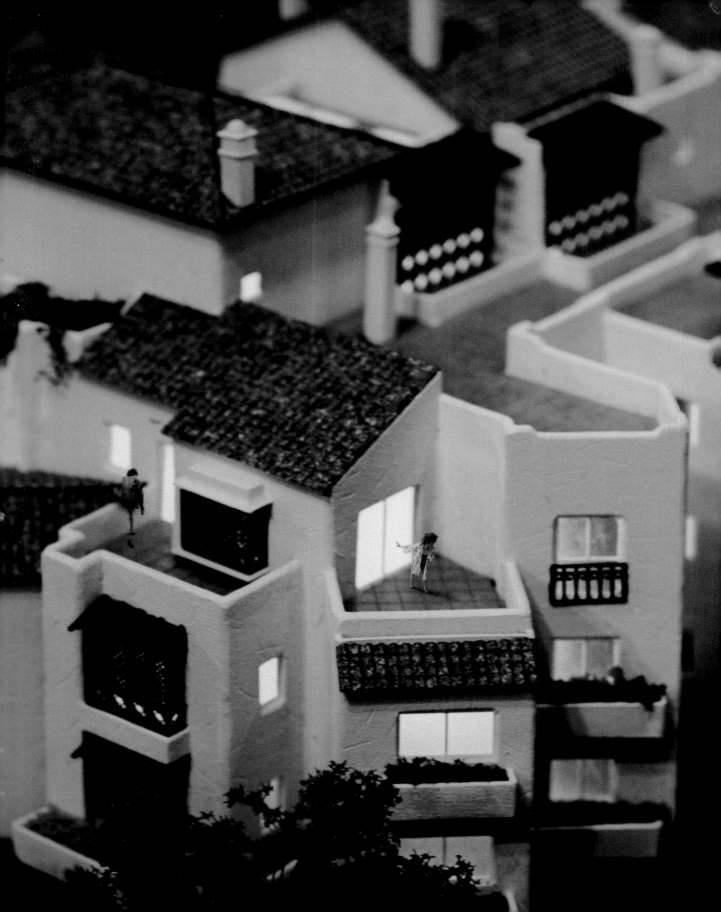

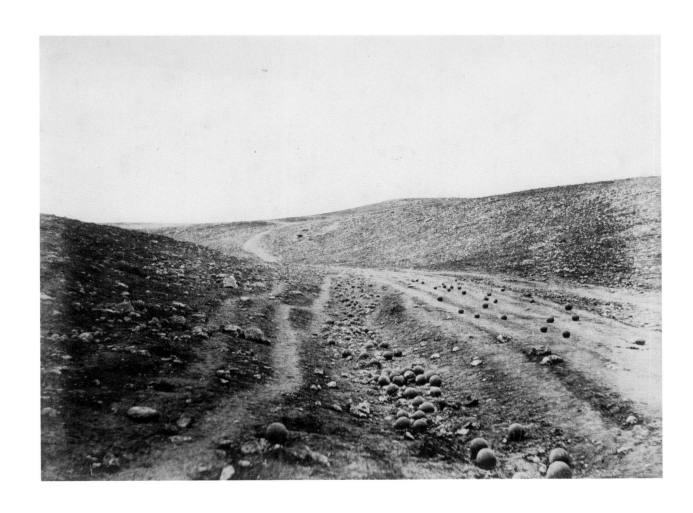

Roger Fenton (1819–1869)

Valley of the Shadow of Death
1855

Albumen print
27.2 x 36.3 cm

(detail p.1)

Fenton was sent to the Crimea in 1855 to document the war. Using glass plate negatives, he was unable to record split-second action. Instead, he captured the haunting aftermath of the battlefield. He made two versions of this image: one with the cannonballs strewn over the road, and one without. The extent to which he 'staged' the photographs remains a point of speculation.

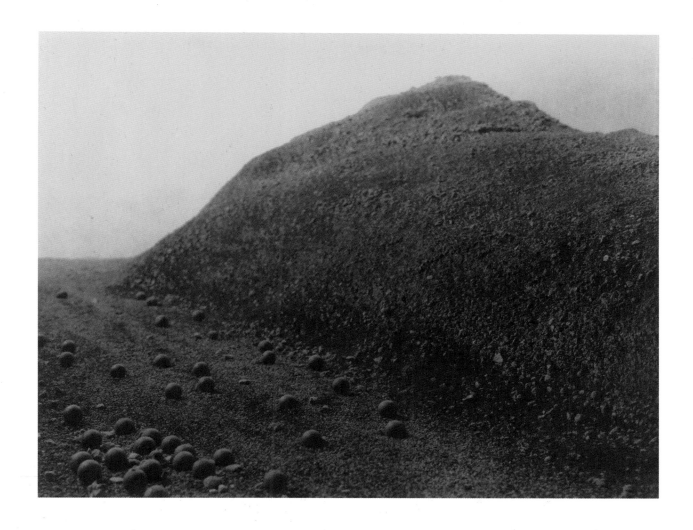

Terry Towery (b.1963)
aka Timothy Eugene O'Tower (1829–1905)

View of Crimean War Battle Scene
2006

Platinum print
22.9 x 30.5 cm

Towery claims to have 'discovered' this photograph by his forebear Timothy Eugene O'Tower, a nineteenth-century photographer. O'Tower's work bears an uncanny resemblance to that of several other Victorian photographers, such as Roger Fenton. O'Tower is in fact a figment of Towery's imagination, and this photograph shows a table-top construction masquerading as a landscape.

Keith Arnatt (1930–2008)

Canned Sunset
1990

C-type print
51 x 51 cm

Arnatt's background as a sculptor and conceptual artist is evident in his close-up photographs of objects found at rubbish tips. This richly coloured image depicts a sunset, a natural phenomenon associated with romance and beauty, formed from the detritus of human consumption.

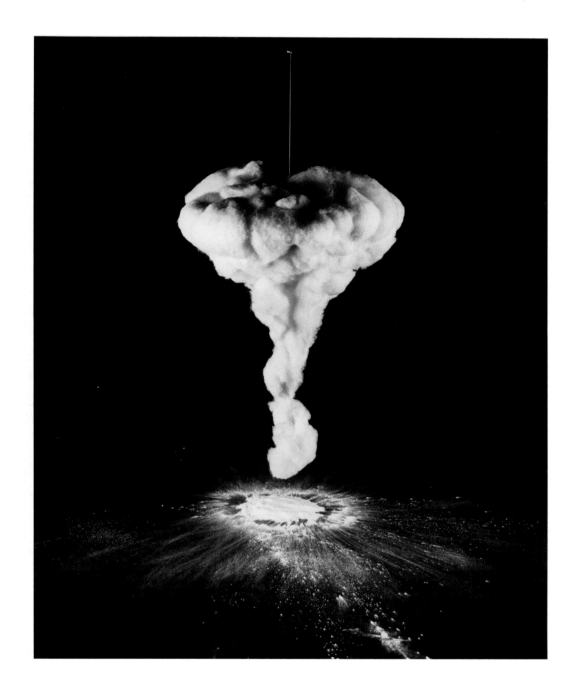

Tess Hurrell (b.1975)

Chaology no.1
2006

Gelatin silver print
58 x 46.7 cm

Hurrell has constructed a series of models and installations for the series *Chaology*. Using materials such as cotton wool and talcum powder, she creates dynamic images of what appear to be explosions. For this project, the artist drew inspiration from known images of Hiroshima, nuclear test facilities, the space shuttle disaster and bombs going off.

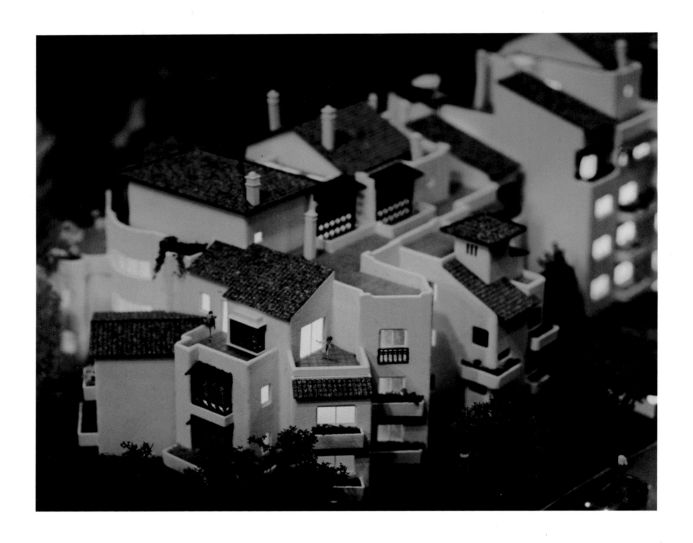

Xing Danwen (b.1967)

Urban Fiction, no. 23
2005

Digital C-type print
170 x 212.5 cm

(detail p.171)

The building in this photograph is a sales model for a new development. The artist digitally inserts herself into the image, enacting multiple roles in a miniature domestic drama. The series *Urban Fiction* expresses the artist's feelings about urban life in China today, which she feels can be lonely, psychologically isolating and unreal.

Oliver Boberg (b.1965)

Anliegerweg (Residents' Path)
2000

C-type print
93.9 x 68.2 cm

Boberg's photographs feature the type of urban location favoured by many contemporary photographers. However, the scenes are not real. He photographs a place, makes models of it in his studio and, finally, photographs the models. 'I try to keep my motifs free of everything that is individual about a certain place and to present a place in a general way, so that anyone can imagine it for themselves.'

Bridget Smith (b.1966)

Glamour Studio (Locker Room)
1999

C-type print
90 x 122.5 cm

This locker room is not what it might
appear to be at first glance. It is, in fact,
a constructed set used in the pornography
industry to stage a particular sexual
fantasy. Smith's work often deals with
spaces that are intended for a performance,
from cinemas to sound studios. For her,
these spaces are poised, awaiting the event
that makes sense of them.

Anne Hardy (b.1970)

Untitled IV (balloons)
2005

C-type print
120 x 150 cm

(detail p.2)

Hardy constructs elaborate sets in her studio
and fills them with discarded objects and
materials found in urban environments. The
sets are meticulously fashioned and can take
many months to make, but exist only for the
purpose of being photographed. The places
depicted are unsettling and often chaotic. They
can appear recently vacated, leaving a sense of
broken narrative or unfinished performance.

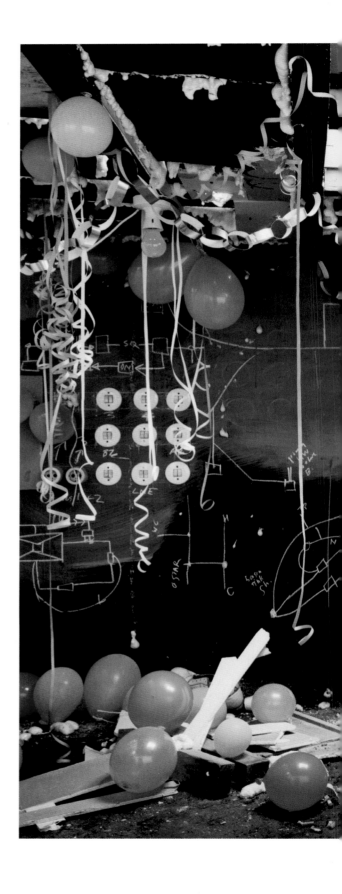

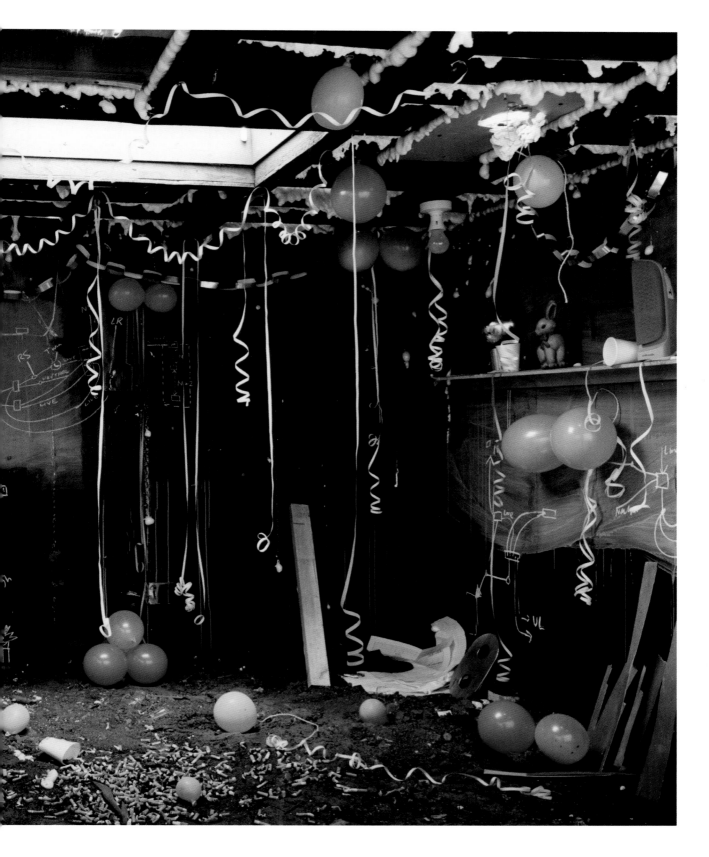

Further Reading

Quentin Bajac, *Tableaux vivants : Fantaisies photographiques victoriennes (1840–1880)* (Paris 1999)

Simon Baker and Fiontán Moran (eds), *Performing for the Camera* (London 2016)

Jennifer Blessing, *Rrose is a Rrose is a Rrose: Gender Performance in Photography* (New York 1997)

Elaine K. Dines-Cox, *Anxious Interiors: An Exhibition of Tableau Photography and Sculpture* (Laguna Beach 1984)

Kathleen A. Edwards, *Acting Out: Invented Melodrama in Contemporary Photography* (Iowa City 2005)

Mia Fineman, *Faking It: Manipulated Photography before Photoshop* (New York 2012)

Erin C. Garcia, *Photography as Fiction* (Los Angeles 2010)

Anne H. Hoy, *Fabrications: Staged, Altered, and Appropriated Photographs* (New York 1987)

Hope Kingsley, *Seduced by Art: Photography Past and Present* (London 2013)

Michael Kohler, *Constructed Realities: The Art of Staged Photography* (Zurich 1995)

Joanna Lowry and David Green (eds), *Theatres of the Real* (Brighton and Antwerp 2009)

Lori Pauli (ed.), *Acting the Part: Photography as Theatre* (London and New York 2006)

Phillip Prodger, *Victorian Giants: The Birth of Art Photography* (London 2018)

Diane Waggoner (ed.), *The Pre-Raphaelite Lens: British Photography and Painting, 1848–1875* (Washington 2010)

Marta Weiss, *Julia Margaret Cameron: Photographs to electrify you with delight and startle the world* (London 2015)

Picture Credits

The following list of artists provides, for reference, Victoria and Albert Museum object numbers for included works. Those with collection reference letters RPS belong to the Royal Photographic Society Collection, Victoria and Albert Museum, acquired with the generous assistance of the Heritage Lottery Fund and Art Fund.

Keith Arnatt (1930–2008)
p.176 E.2300-1997
© Keith Arnatt Estate. All Rights Reserved, DACS 2018

Richard Avedon (1923–2004)
p.148 E.1256-1993
p.149 E.1255-1993
Photographs by Richard Avedon. Copyright © The Richard Avedon Foundation

Emma Barton (1872–1938)
p.75 RPS.1246-2108

Walter Bird (1903–1969)
p.63 RPS.79-2018

Oliver Boberg (b.1965)
p.179 E.8-2002
 Given by BMW Financial Services Group.
© Oliver Boberg. Courtesy L.A.Galerie, Frankfurt am Main

Leonida Caldesi (1822–1891) and **Mattia Montecchi** (1816–1871)
p.60 68040
 Townshend bequest.

Julia Margaret Cameron (1815–1879)
p.19 85-1970
 Given by Mrs Agnes May Ffytche, 1927.
p.55 45148
p.59 RPS.771-2017
p.61 PH.240-1982
 Given by Mrs Margaret Southam, 1941.
p.67 RPS.708-2017
p.68 46-1939
 Given by Mrs Ida S. Perrin, 1939.
p.72 45155
p.73 44765
pp.113 (detail) and 119 44780

W.G. Campbell (1810–1881)
p.139 RPS.1211-2018

Robert Thompson Crawshay (1817–1879)
p.159 PH.9-1984

Gregory Crewdson (b.1962)
pp.12 (detail) and 24–5 E.472-2009
 Purchased with the support of the Friends of the V&A and the American Friends of the V&A through the generosity of Mr and Mrs Hugues Lepic.
© Gregory Crewdson. Courtesy Gagosian

Gohar Dashti (b.1980)
p.45 E.823:4-2014
 Purchased through the Cecil Beaton Fund.
© Gohar Dashti

F. Holland Day (1864–1933)
p.89 RPS.2297-2017

Mary Dillwyn (1816–1906)
p.49 PH.181-1984

Charles Lutwidge Dodgson (aka **Lewis Carroll**) (1832–1898)
p.18 E.145-2009
 Given by Noelene Grant.
p.129 RPS.2235-2017
p.156 RPS.2248-2017
p.157 RPS.2247-2017

James Elliott (1835–1903)
pp.64–5 107-1957
p.93 679-1943

Roger Fenton (1819–1869)
pp.1 (detail) and 173 RPS.2390-2017
p.155 RPS.2341-2017

Charles Furne (1824–1880) and **Henri Tournier** (1835–1885)
p.141 124-1957

Philippe Halsman (1906–1979)
pp.134–5 RPS.2344-2017
© Philippe Halsman/Magnum Photos

Anne Hardy (b.1970)
pp.2 (detail) and 182–3 E.439-2006
 Purchased through the Cecil Beaton Fund.
© Anne Hardy. Courtesy Maureen Paley, London

Clementina, Lady Hawarden (1822–1865)
p.114 PH.274-1947
p.115 PH.271-1947
p.116 PH.356-1947
p.117 PH.358-1947
 All given by Lady Clementina Tottenham.

Tom Hunter (b.1965)
p.85 E.407-1998
p.86 E.408-1998
 Purchased through the Cecil Beaton Fund.

Tess Hurrell (b.1975)
p.177 E.95-2009
© Tess Hurrell

Sarah Jones (b.1959)
pp.153 (detail) and 165 E.1167-1998
© Sarah Jones. Courtesy Maureen Paley, London

Gertrude Käsebier (1852–1934)
p.120 RPS.62-2018

Unknown photographers
p.17 RPS.610-2017
p.31 147-1957
p.35 E.1-1993
p.163 E.953-1993

John A. Walker (b.1938) and **Carolyn Davies** (dates unknown)
p.147 E.558-2001
© John A. Walker and Carolyn Davies

Maxine Walker (b.1962)
pp.108–9 E.303 to 310-2013
 Supported by the National Lottery through the
 Heritage Lottery Fund.
© Maxine Walker. Courtesy Autograph ABP

Jeff Wall (b.1946)
pp.22–3 E.383-1992
© Jeff Wall

Wang Qingsong (b.1966)
pp.96–7 E.557-2008
Courtesy the artist

William Wegman (b.1943)
p.138 E.858-1989
© William Wegman. Courtesy of Senior and Shopmaker

Jan Wenzel (b.1972)
p.169 E.123-2013
 Purchase funded by the Photographs Acquisition Group.
© Jan Wenzel and Kleinschmidt Fine Photographs

Andy Wiener (b.1959)
pp.102–3 PH.340 to 345-1987, 347 to 349-1987

David Wilkie Wynfield (1837–1887)
p.76 136A-1945
p.77 132A-1945

Xing Danwen (b.1967)
pp.171 (detail) and 178 E.916-2010
Courtesy the artist

Madame Yevonde (1893–1975)
p.21 RPS.2348-2017
© The Yevonde Portrait Archive

R.Y. Young (fl.1899–1903)
p.142 RPS.1249-2018
p.143 RPS.1250-2018

Index

Page numbers in **bold** refer to main entries
Page numbers in *italics* refer to illustrations

The Victoria and Albert Museum is the world's leading museum of art and design. Photography has been at the core of its collection since the museum's foundation in 1852. Today, with over 800,000 images dating from 1839 to the present, its photography collection is one of the largest and most spectacular in the world.

The **V&A Photography Library** is a series of books that explores the museum's vast holdings. Each volume focuses on a particular theme, practice or artist, offering the reader fresh insights into the art and culture of photography.

Marta Weiss has been Curator of Photographs at the Victoria and Albert Museum since 2007. She has organized exhibitions and displays at the Princeton University Art Museum, the Metropolitan Museum of Art and the Victoria and Albert Museum, where her exhibitions include *Light from the Middle East* (2012) and *Julia Margaret Cameron* (2015).

For their assistance in preparing this book, I am grateful to Kate Stevens and Rachael Chambers. Thank you also to the rest of the V&A Photographs Team: Martin Barnes, Susanna Brown, Catherine Troiano and Erika Lederman. I am indebted to Keith Lodwick for his theatrical research, Tim Travis for his insight into religious practice, Lori Pauli for her Rejlander knowledge, and Anne Varick Lauder for her Old Master expertise. Kathryn Johnson, Coralie Hepburn, Hannah Newell and Tom Windross at V&A Publishing all helped make this book possible, as did Andrew Sanigar at Thames & Hudson and Lewis Chaplin at Loose Joints. Thank you to all the artists and galleries who contributed images. Mothers, daughters, storytelling and dress-up abound in this book; I dedicate it to my own girls, Athena and Penelope.

M.W.